IMAGES
of America

WOODEN BOATS
OF THE
ST. LAWRENCE RIVER

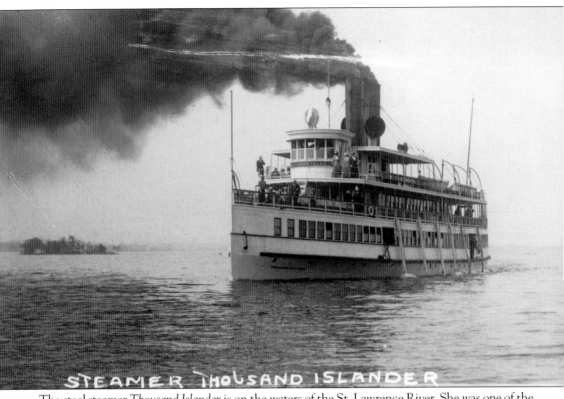

STEAMER THOUSAND ISLANDER

The steel steamer *Thousand Islander* is on the waters of the St. Lawrence River. She was one of the many boats in the Richelieu & Ontario Navigation Company and was used regularly throughout the Thousand Islands. (Courtesy of the Lyon Family Archives.)

ON THE COVER: *Finesse* was launched in the spring of 1933 and was the first collaboration between Charlie Lyon, John L. Hacker, and Fitzgerald & Lee. She is pictured speeding out of Alexandria Bay, with Bonnie Castle in the background. (Courtesy of the Lyon Family Archives.)

IMAGES
of America

WOODEN BOATS
OF THE
ST. LAWRENCE RIVER

David Kunz and Bill Simpson

ARCADIA
PUBLISHING

Published by Arcadia Publishing
Charleston, South Carolina

Printed in the United States of America

Library of Congress Control Number: 2016937115

For all general information, please contact Arcadia Publishing:
Telephone 843-853-2070
Fax 843-853-0044
E-mail sales@arcadiapublishing.com
For customer service and orders:
Toll-Free 1-888-313-2665

Visit us on the Internet at www.arcadiapublishing.com

This book is dedicated to our families and friends.

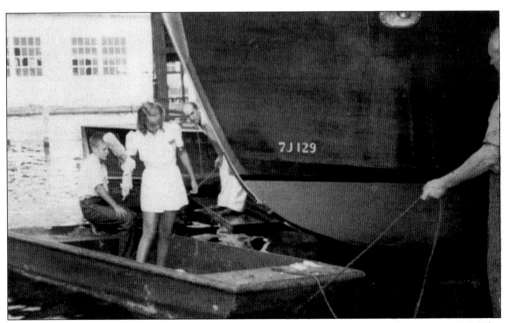

This photograph is of Bert Hutchinson's daughter, Aletha, christening *Pardon Me* in 1947. The one-of-a-kind Hutchinson was built in Alexandria Bay after World War II. (Courtesy of the Antique Boat Museum.)

CONTENTS

ACKNOWLEDGMENTS

This book would not have come about without the invaluable contribution of the following people: the Lyon family; the Griffin family; Hans and Kelly Kunz; Robert and Jonathan Kunz; Janine Betts; the Simpson family; David and Robyn Johnsen and family; Tom Wood and the entire Wood clan; Les and Jeanie Young and family; the Fox family; Taylor and Julian Kucharski and family; Chris Waterbury and family; James Wright and family; Andrew Schneeberger and family; Mark Post and family; the Collins family; the Quarrier family; the Bonisteel family; the Benton family; Tony Mollica Jr.; Claire Wakefield; Dave Rogers; Andrew Knap; Michael Corrigan; Jamie St. Onge; Bud Gray; Jim Mellowship; Sam Hopkins; Ian Coristine; Bill Schoeder; and Robert and Patty Mondore. The following organizations also helped this book come to fruition: the Lyon Family Archives; the Antique Boat Museum, Clayton, New York; the Antique and Classic Boat Society; the Alexandria Township Historical Society; and the Mariners' Museum, Newport News, Virginia.

Unless otherwise noted, all images are courtesy of the Lyon Family Archives.

INTRODUCTION

The Thousand Islands—those who have seen them never forget.

Earth is littered with beautiful, breathtaking scenery, like the Grand Canyon, the Swiss Alps, Yosemite Falls, the Serengeti, and the St. Lawrence River.

Do yourself a favor and take a cruise through the Thousand Islands in an antique wooden boat, preferably a triple-cockpit Gar Wood runabout.

Cruise from Alexandria Bay to Chippewa Bay. Along the way, you will pass Boldt Castle on Heart Island, designed by the owner of the Waldorf Astoria Hotel in New York City back in 1900 to be one of the largest private homes in America.

Beyond the quiet waters surrounding Heart Island, you will motor past Harbor Island, Manhattan Island, and the Sunken Rock Lighthouse. After passing the Summerlands, the river will widen considerably. Off to your left, across a glistening expanse of water—Canada! It is close enough to touch.

Yeo, Tar, and Doctor Islands all lie just beyond the watery boundary separating Canada and America. Land on Grenadier Island and play its classic nine-hole golf course, no passport required.

Motor on at a leisurely pace and pass by Ironsides. If it is spring, you will likely see hundreds of great blue herons returning to their roosts after wintering in warmer climes.

Farther downriver find Hemlock Island, Halfway, St. Margarettes, and Jug, rugged islands protected by a rim of ancient rocks and towering trees that throw shadows across the surface of the river.

You will pass fishermen, sailors, water-skiers, and kayakers as you motor by Scow and Rabbit with Dark Island now visible in the distance. Dominating Dark Island will be the massive Singer Castle, an eruption of earth and stone right smack in the middle of the St. Lawrence River.

Hug tight against the western shore of Oak Island and have the old Gar Wood move slowly, not much above an idle—this is no place to hurry—until the home built by David Lyon back in 1907 comes into view. The large, rambling house sits on a prominent rock outcropping. In an instant, you realize it was built in this exact location to absorb all the majesty and beauty the Thousand Islands have to offer.

Take a slow spin through Lookout Bay and see where some of the most powerful and attractive wooden boats ever to grace the St. Lawrence River were berthed. *Finesse*, *Vamoose*, and *Pardon Me* all called Oak Island home.

Beyond Oak Island, you pass Owatonna, Rob Roy, and Ragnavok. The old Gar weaves between Atlantis and Twilight and takes you across the calm bay to the public dock at Chippewa where you will refuel for the memorable journey home.

Like the Road to the Sun across Glacier National Park, like Skyline Drive through the blue Shenandoah, like a river cruise down the Rhine, like a long hike up Tuckerman's Ravine to the summit of Mount Washington, a cruise through the Thousand Islands in an antique wooden boat is one of life's great pleasures and must-do events.

Located on the St. Lawrence Seaway between New York State and the province of Ontario, the Thousand Islands stretch northeast from the mouth of Lake Ontario past the tranquil waters of Chippewa Bay.

There are, in fact, 1,864 islands in the Thousand Islands. The largest, Wolfe Island, is nearly 50 square miles and has a year-round population of over 1,400.

Hundreds of small islands dot this magnificent stretch of the St. Lawrence River. Most are nothing but rock, and some are not much larger than a postage stamp. But as long as the rock remains above water year-round and supports at least one living tree or bush, it is an official member of the Thousand Islands family of islands.

Native Americans who made the Thousand Islands region their home for countless generations called the area Manitouana, the Garden of the Great Spirit.

In the last decades of the 19th century, wealthy American industrialists and financiers discovered the Thousand Islands. They bought entire islands; designed and built fabulous vacation homes; and founded hunting clubs, fishing clubs, and yacht clubs.

And, of course, they built boats, including motorboats, sailboats, small skiffs, and great cruising yachts. They needed boats to transport themselves and their guests out to their islands. And they needed boats for recreation. Being brash, competitive men by nature, they all needed to have the biggest, fastest, fanciest boats.

This is the story, in pictures, of those men, especially David and Charlie Lyon, of Oak Island, who epitomized the hard work and sporting spirit that made the Thousand Islands such an interesting and unique place.

One

BOATS OF THE ST. LAWRENCE RIVER

The native Iroquois traversed the waters of the St. Lawrence River as far back as the 14th century. Birch-bark and dugout canoes were their primary modes of transportation. They used the great and bountiful river as both a means of conveyance and as a rich source of food.

In the summer of 1534, the intrepid explorer Jacques Cartier became the first European known to explore the St. Lawrence River. A year later, on his second expedition to the New World, Cartier sailed his four-masted carrack as far down the river as present-day Montréal. There, his flotilla of three ships and 100 men turned back due to turbulent waters and chaotic rapids.

Those blunt, oceangoing, wooden sailing ships, with their square sails billowing in the breeze, must have been quite a sight tacking up the St. Lawrence River nearly 500 years ago, just as they would be quite a remarkable sight today.

Tens of thousands, possibly hundreds of thousands, of watercraft, including barges, ferries, launches, runabouts, sailboats, skiffs, yachts, and yawls, have plied the waters of the St. Lawrence River in the centuries since Cartier's explorations.

The last decades of the 19th century and the first decades of the 20th century were the heyday of boating on the St. Lawrence River. Giant steamships were built to ferry visitors up and down the great river from Kingston at the mouth of Lake Ontario all the way north to Québec City and beyond.

And when the big moneymen—like Boldt, Bourne, Emery, Lyon, Peacock, and Pullman—decided to make the Thousand Islands region of the St. Lawrence River their summer playground, the proliferation of boats exploded.

This arrival of affluence brought about the opening of new boatyards in Ogdensburg and Alexandria Bay. Craftsmen flocked to the region. Yacht clubs sprang into existence. Racing competitions emerged. Sailboat races and speedboat races became all the rage.

In 1905, the Gold Challenge Cup had its inaugural races on the St. Lawrence River in Chippewa Bay. Well-heeled participants had custom-designed wooden speedboats built to compete in the races. Within a few years, the Gold Cup became the premier speedboat racing event in North America. Every year, new boats with fresh designs and more powerful motors entered the competition.

Boats have played a powerful role in the history of the St. Lawrence River since the days of the Iroquois and the early European explorers. To stare out at the river is to watch history float by.

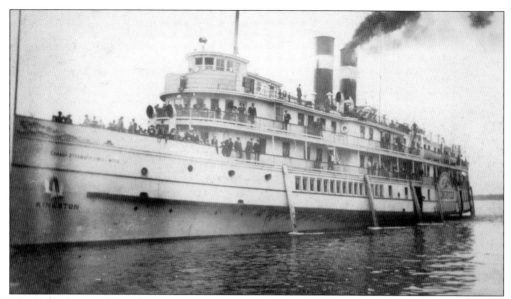

The Richelieu & Ontario Navigation Company has roots as far back as 1845. This company could take passengers from Toronto, 778 miles north, to the Gulf of St. Lawrence. One of its most recognized steamships, *Kingston*, is shown here.

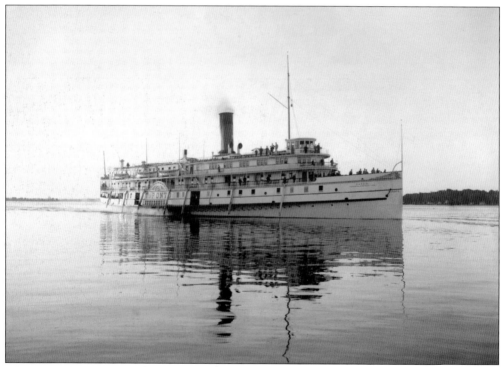

The steel steamer *Toronto* was one of Richelieu & Ontario Navigation Company's flagships. In its fleet, *Toronto*, *Kingston*, *Montreal*, and *Quebec* were the company's most popular boats. In the early 1900s, the cost of a trip from Toronto to Alexandria Bay was $5.60.

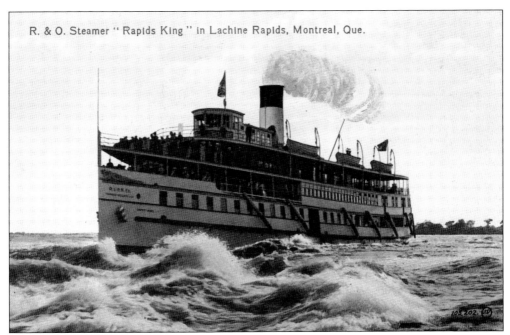

R. & O. Steamer " Rapids King " in Lachine Rapids, Montreal, Que.

During the late 1800s and early 1900s, interest in the Thousand Islands grew dramatically. Train cars would drop visitors off at the waterfront in places like Clayton, New York. From there, they would get on steamboats, like the *Rapids King*, and be taken all around the St. Lawrence River.

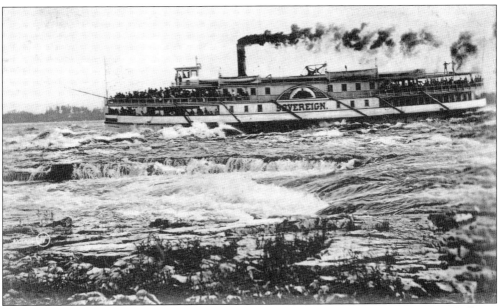

The steamer *Sovereign* is shown in the Lachine Rapids near Montréal. These rapids were a challenge to navigate, but provided a thrilling ride for passengers.

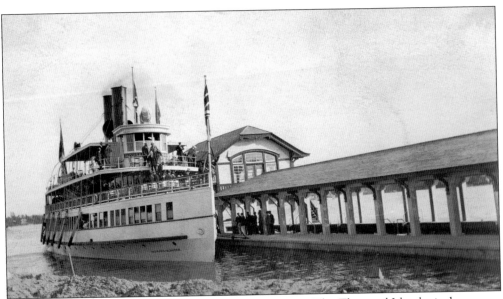

The *Thousand Islander* is shown above at the docks of the Thousand Islands Club. This vessel was launched in 1912 and was used between Clayton and Ogdensburg. The Richelieu & Ontario Navigation Company operated these steamships day and night.

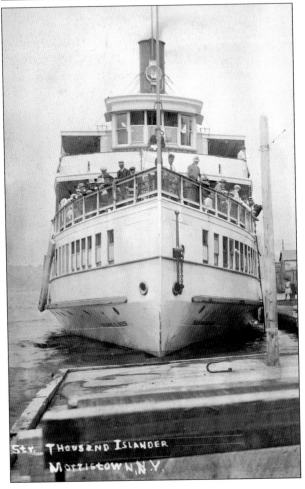

The *Thousand Islander* was capable of carrying 700 passengers at a time. She is shown at left at the Morristown docks. As the years passed, the Richelieu & Ontario Navigation Company established itself as the premier steamship line on the St. Lawrence River. The company virtually bought out all of the competition.

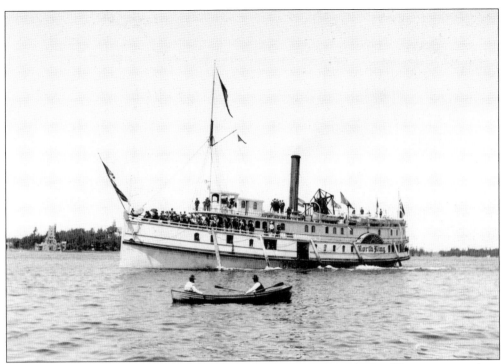

Richelieu & Ontario Navigation Company's slogan was "Niagara to the Sea." Frequent stops along the way were Toronto, Kingston, Clayton, Alexandria Bay, Brockville, Montréal, and Québec. The Steamer *North King* is shown here in front of Boldt Castle.

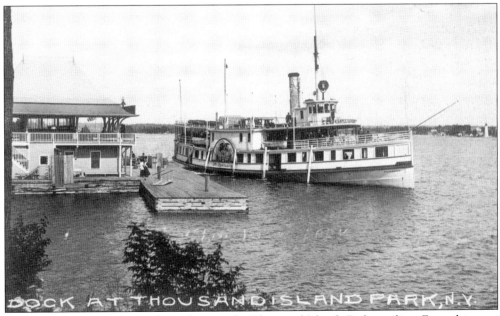

The steamer *St. Lawrence* is shown leaving the Thousand Islands Park pavilion. From this stop, it would travel to either Alexandria Bay or Round Island.

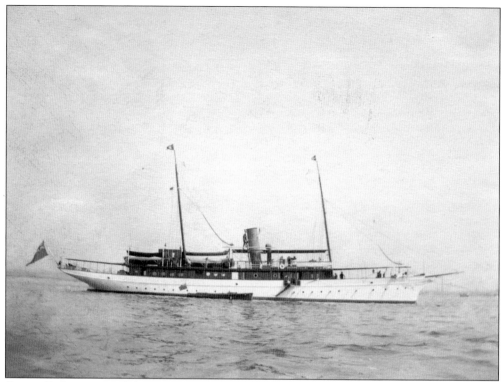

Garnet P. Grant owned the 152-foot steam yacht *Solgar*. She was designed by G.L. Watson and built by Fleming & Ferguson in Paisley, Scotland, in 1891. Note the small launch tied up on the starboard side.

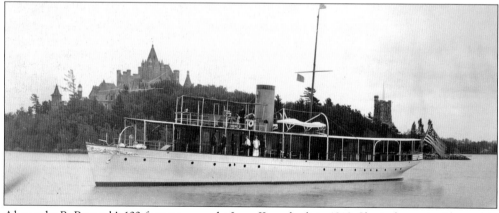

Alexander R. Peacock's 122-foot steam yacht *Irene II* was built in 1910. She is shown in Alexandria Bay in front of Boldt Castle. Peacock's yacht house was one of the grandest in the Thousand Islands. Peacock made his fortune with Carnegie Steel and was a member of the Thousand Islands Yacht Club, the Frontenac Yacht Club, and the Chippewa Yacht Club.

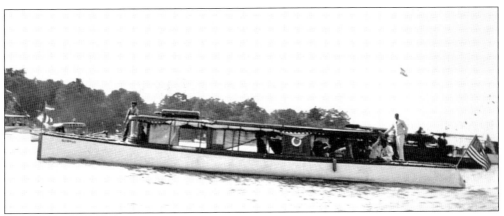

Joseph Leyare is regarded as one of the St. Lawrence River's most impressive boatbuilders. He was responsible for building numerous boats, including *Ojibway* for the Honorable E.B. Hawkins. *Ojibway* was 55 feet long with a 60-horsepower Leighton engine. (Courtesy of the Antique Boat Museum.)

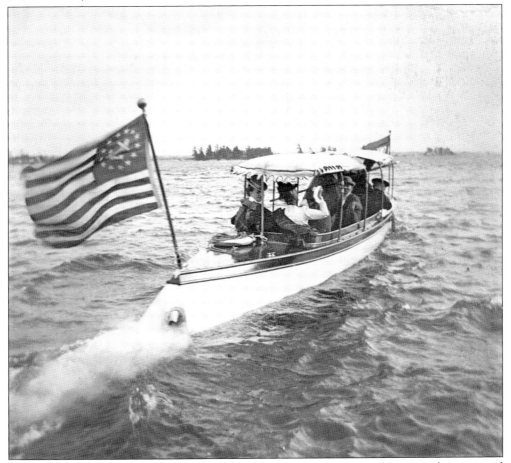

Boat design began to evolve as the transition was made from steam yachts to gasoline-powered launches. James P. Lewis's canopy launch is shown on the St. Lawrence River. Lewis was a member of the prestigious Frontenac Yacht Club.

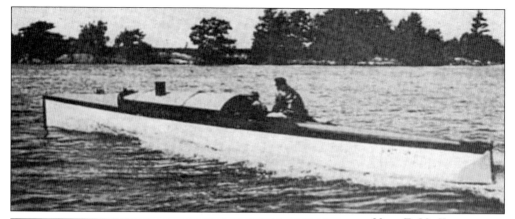

Vingt-Et-Un II, or *Twenty-One II*, won the Chippewa Yacht Club its first Gold Challenge Cup in 1904 on the Hudson River. Her owner, Willis Sharp Kilmer, made his fortune selling a medicine called "Swamp Root." (Courtesy of *Field & Stream* magazine, 1904.)

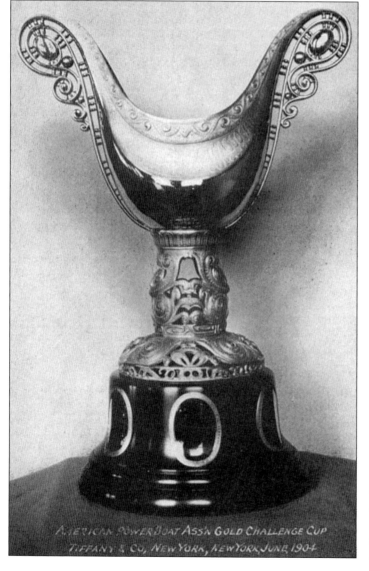

The original Gold Challenge Cup trophy is shown here. A yacht club from the Thousand Islands held this trophy for nine years in a row. The Chippewa Yacht Club won the first four, the Thousand Islands Yacht Club won four, and the Frontenac Yacht Club won one. The Gold Challenge Cup is the oldest active trophy in motorized sports. (Courtesy of the Antique Boat Museum.)

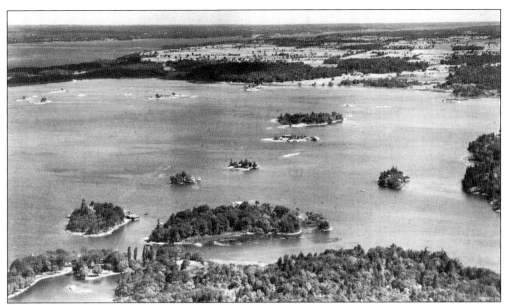

Chippewa Bay, New York, is shown from above. The Chippewa Yacht Club was formed in 1895. Some of the river's most prominent residents have been past members, including George Boldt, Frederick Bourne, Alexander Peacock, and Charles Emery.

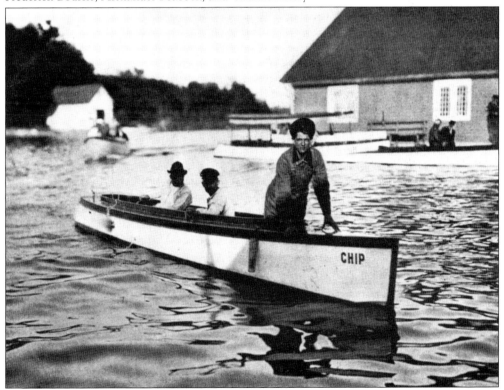

Joseph Leyare built *Chip* in Ogdensburg, New York, for Jonathan Wainwright. She won the 1905 Gold Challenge Cup for the Chippewa Yacht Club on its course in Chippewa Bay. (Courtesy of the Antique Boat Museum.)

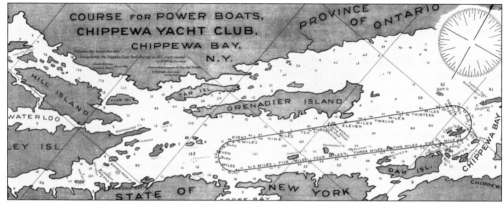

The Chippewa Yacht Club hosted the Gold Challenge Cup races from 1905 to 1908. This map shows the racecourse from 1905. This was the first time the Gold Cup races would be hosted on the St. Lawrence River. The start of the race was off the state park docks on Cedar Island.

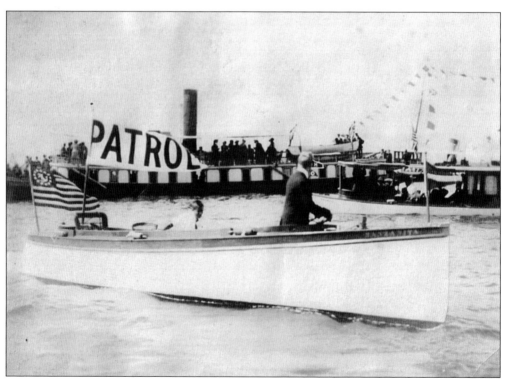

Thomas Knap and David Lyon were on the racing committee for the 1905 races. The patrol boat *Manzanita* is shown with Knap in the bow.

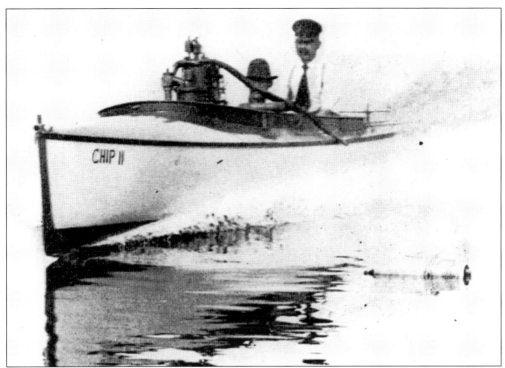

Chip II won the Gold Challenge Cup for the Chippewa Yacht Club in 1906 and 1907. Joseph Leyare also built this race boat for Jonathan Wainwright. (Courtesy of the Antique Boat Museum.)

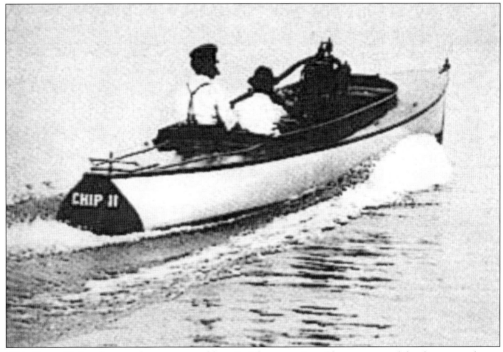

Chip II was 30 feet long and was powered by a Leighton engine. She was one of the first motorboats to have a supercharger on the engine. (Courtesy of the Antique Boat Museum.)

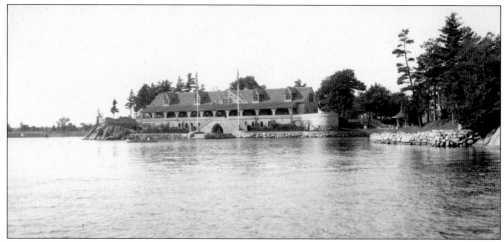

In 1907, E.J. Schroeder's *Dixie* won America its first Harmsworth Trophy, the British International Trophy for Motorboats established by Alfred Harmsworth. Shortly after that, George Boldt recruited Schroeder to join the Thousand Islands Yacht Club. The yacht club had its clubhouse on Welcome Island in Alexandria Bay.

In 1908, Schroeder won the Harmsworth Trophy again, this time with his new boat, *Dixie II*, a hydroplane. Capt. S. Bartley Pearce held his unconscious (from inhaling exhaust fumes from the motor) engineer Albert Rappuhn with one hand as he steered *Dixie II* across the finish line.

In 1908, *Dixie II* defeated *Chip III* for the Gold Cup, ending the Chippewa Yacht Club's four-year winning streak. Chippewa never hosted the race again. *Dixie II* was the first hydroplane on the St. Lawrence River and would win the Gold Challenge Cup and the Harmsworth Trophy in 1909 and 1910 before retiring.

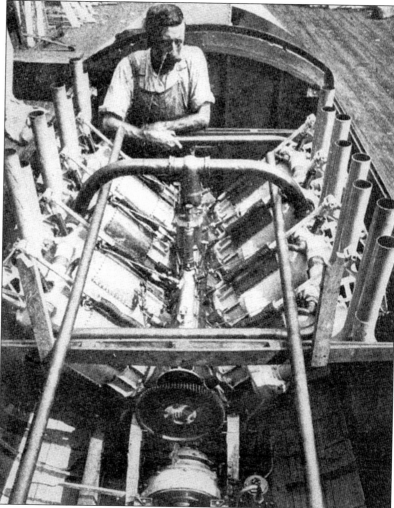

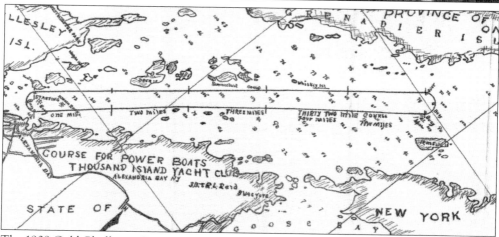

The 1909 Gold Challenge Cup races were hosted by the Thousand Islands Yacht Club thanks to *Dixie II*. The racecourse map from 1909 is shown here.

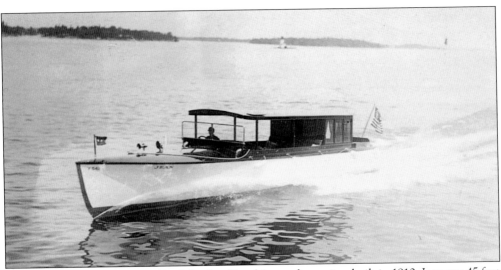

Commodore James Hammond had the first Hutchinson day cruiser built in 1910. *Jean* was 45 feet long and capable of speeds of 27 miles per hour. Hammond was commodore of the Thousand Islands Yacht Club. (Courtesy of the Antique Boat Museum.)

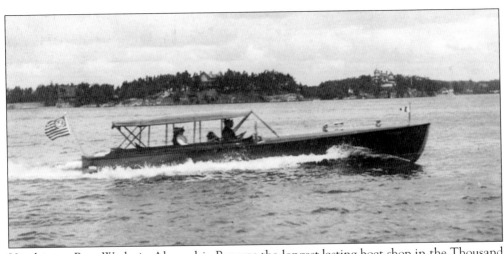

Hutchinson Boat Works in Alexandria Bay was the longest-lasting boat shop in the Thousand Islands. *Thais* was built in 1914 for A.O. Miller. She was a convertible launch and was capable of going 24 miles per hour. (Courtesy of the Antique Boat Museum.)

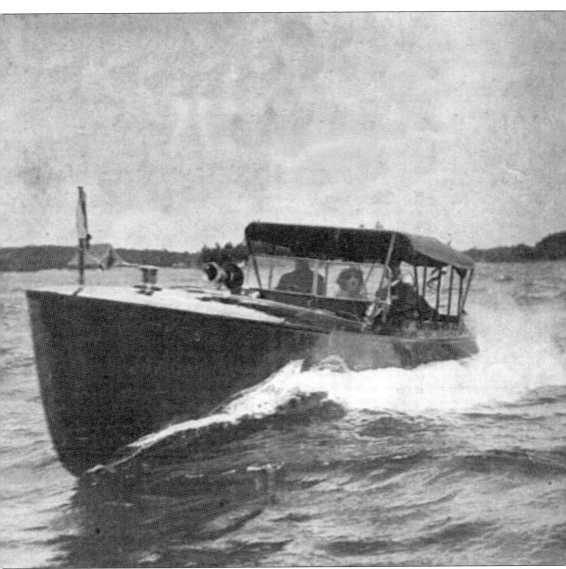

Thais brought national attention to Hutchinson Boat Works when she was on the front cover of *Motor Boat* magazine in 1914. The magazine had an article that praised Hutchinson's workers for their expert craftsmanship on this design. *Thais* was 36 feet long and had a 75-horsepower Sterling motor. (Courtesy of the Antique Boat Museum.)

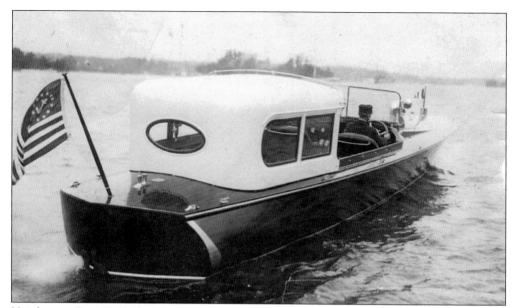

Hutchinson Boat Works built *Voyager* in 1919. She was a unique launch with a modern aluminum top that covered the stern. The top was designed to resemble an automobile cover. (Courtesy of the Antique Boat Museum.)

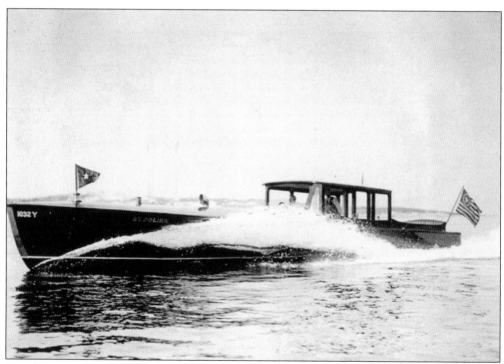

Hutchinson Boat Works also built *Bobolink* in 1920 for Quincy Bent. The 42-foot-long *Bobolink* was a hard-topped launch that was made of solid mahogany. (Courtesy of the Antique Boat Museum.)

Fitzgerald & Lee of Alexandria Bay was an up-and-coming outfit in the early 1920s. It specialized in maintaining and selling Gar Wood runabouts to the Thousand Islands residents. By 1928, the company would be known as the nation's most successful Gar Wood dealer. (Courtesy of the Antique Boat Museum.)

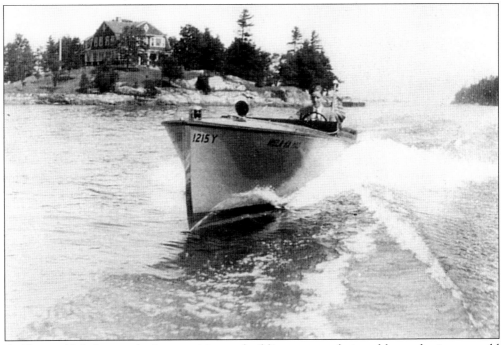

As Fitzgerald & Lee made the transition to building custom-designed boats, business would expand rapidly. The company built *Wela Ka Hoa* in 1927 for H.P. Wilbur. (Courtesy of the Antique Boat Museum.)

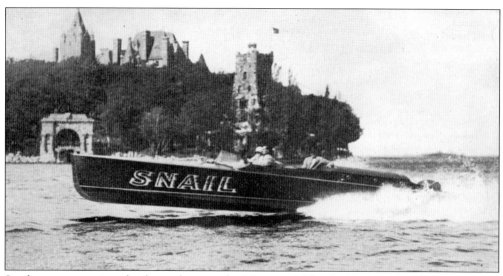

Snail was at one time the fastest boat in the Thousand Islands. Her owner, Edward J. Nobel, president of Life Savers Candy, offered anyone who could beat him in a race $1,000. This Baby Gar was 33 feet long and capable of speeds of 55 miles per hour. (Used with permission of the Antique & Classic Boat Society, Inc.)

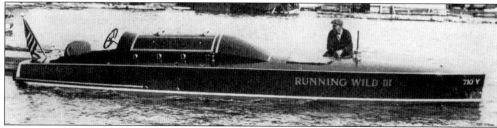

It has been widely debated whether or not *Running Wild III* stole the crown from *Snail* as the fastest boat on the river. Roy Stanley's Stanley Boat Works built this Hacker-designed speedboat in Cape Vincent, New York. (Used with permission of the Antique & Classic Boat Society, Inc.)

Two

THE THOUSAND ISLANDS

Bourne, Lyon, Emery, Boldt, Pullman, and Wyckoff are important names in the distinguished history of America's rise to economic and industrial prominence. These are also the men who entirely altered the landscape of the Thousand Islands at the end of the 19th century and beginning of the 20th century.

Before the arrival of these hard-driving and ambitious men, the Thousand Islands had remained virtually unchanged since the Ice Age. Native Americans inhabited the region in small numbers for thousands of years. Jacques Cartier explored the St. Lawrence River in 1535. Forts were built by the French and British in the 17th and 18th centuries. Small villages sprang up. Hard men eked out a living. But the beautiful, remote islands from Kingston to Brockville remained mostly undeveloped and uninhabited until the second half of the 19th century.

Tobacco, transportation, finance, train cars, and hotels are the endeavors that built the Thousand Islands into a posh summer playground for the well-heeled. Islands up and down the river were purchased for a pittance. Renowned architects like G.W. Hewitt (Boldt Castle) and Ernest Flagg (the Towers, later renamed Singer Castle) were hired to design massive and magnificent homes on the rocky, isolated islands. Castle Rest, Carlton Villa, the Stone House, Boldt Castle, and the Towers were the monuments built by men who had amassed great fortunes back before the days of personal income tax and government redistribution of wealth programs. The development of their islands and the construction of their enormous homes created excellent employment opportunities. Architects, engineers, carpenters, masons, dock builders, and laborers came to the region looking for work. Whole new towns emerged. Money flowed, and the local economy boomed.

The arrival of wealth was a boatbuilder's dream. This meant big contracts, new designs, and well-dressed men at the door with pockets bulging with money. They all wanted boats. Powerboats, sailboats, and runabouts were in high demand. It was a watery world they were creating, and one needed a boat the way a city-dweller needed a horse and buggy.

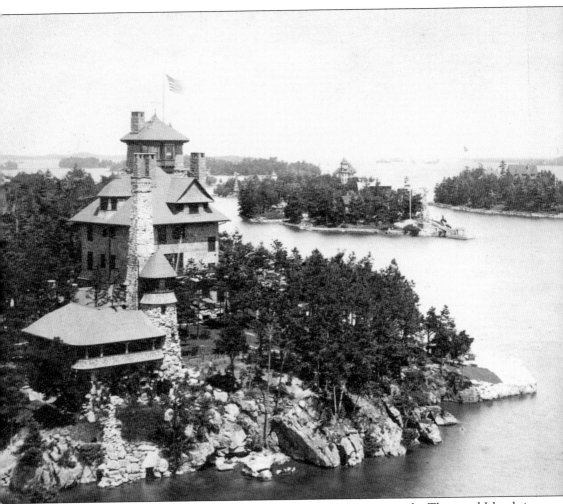

George M. Pullman was responsible for bringing national attention to the Thousand Islands in 1872 when Pres. Ulysses S. Grant visited him on Pullman Island in Alexandria Bay. In 1888, Pullman replaced his original wooden cottage and built a six-story castle. Castle Rest, as it was known, was the first of many extravagant homes built in the Thousand Islands. Pullman designed the Pullman sleeping car in 1864, and it became a national success. Thirty years later, during the tragic Pullman Strike, George hid out at Castle Rest while President Cleveland dealt with the crisis.

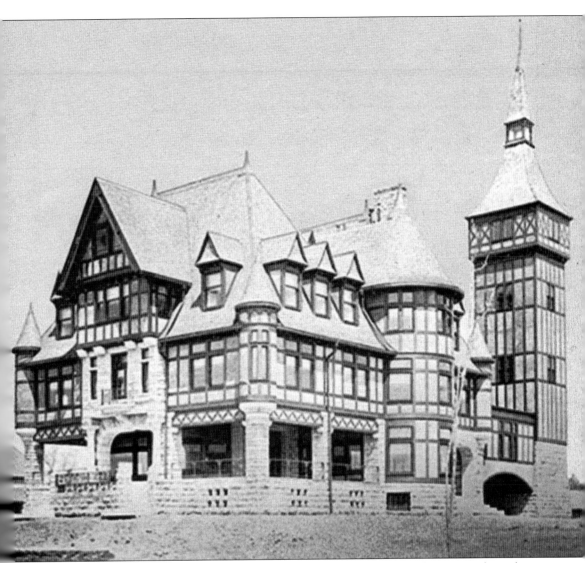

Carleton Villa was built in 1894 for William O. Wyckoff. Wyckoff made his fortune by making the Remington typewriter an international success. The villa is situated at the head of Carleton Island, overlooking Cape Vincent, Wolfe Island, and Lake Ontario. The four-story mansion was second to none in the Thousand Islands. Wyckoff spent only one night in the villa, passing away in his sleep. Since then, it has fallen into extreme disrepair.

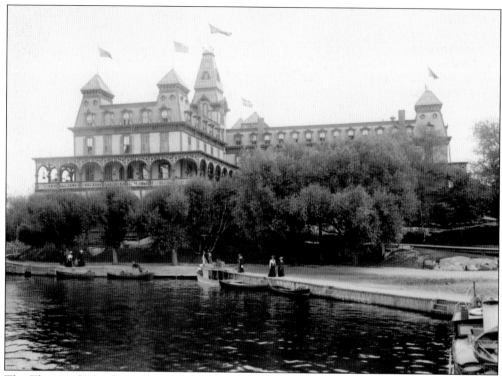

The Thousand Islands are known as a region with excellent fishing opportunities. Charles and Ester Crossman built the Crossman House in Alexandria Bay in 1848 as a fisherman's tavern. The hotel was expanded in the 1880s, as the river's popularity increased.

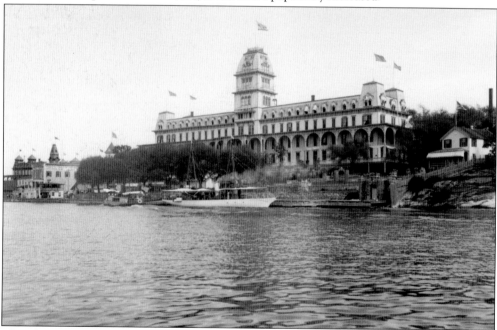

The Thousand Islands House was built to accommodate the surplus of visitors that came to the St. Lawrence River. This hotel was located in Alexandria Bay at the site of River Hospital.

In 1883, the luxurious 400-room Thousand Islands Park Hotel was built on Wellesley Island. On August 23, 1890, the four-story hotel burned to the ground.

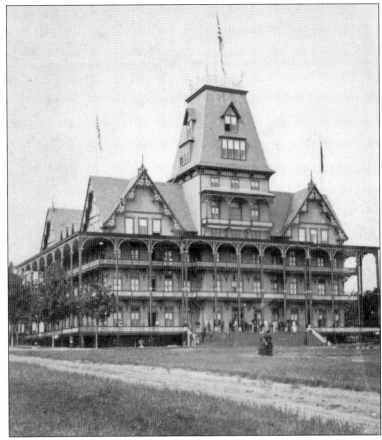

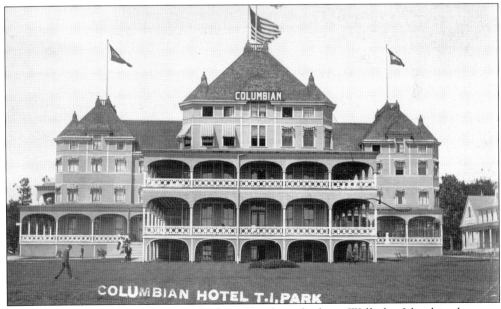

Two years later, the extravagant Columbian Hotel was built on Wellesley Island in the same location. Sadly, in 1912, it too was destroyed by fire.

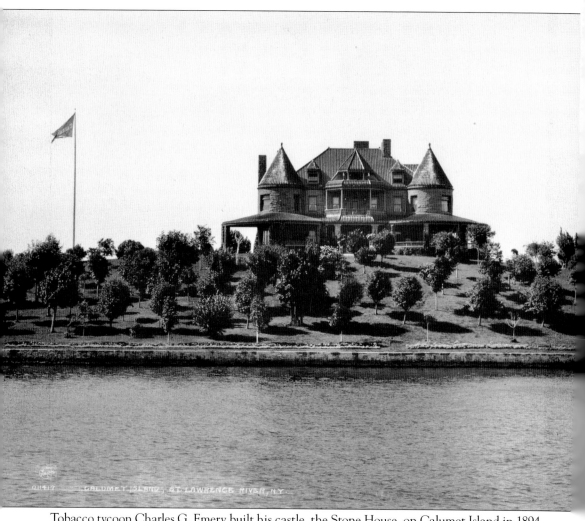

Tobacco tycoon Charles G. Emery built his castle, the Stone House, on Calumet Island in 1894. Emery was referred to as "Lord of the Upper River" and was a friend and rival of George C. Boldt. Both men were successful in the hotel business, and their castles have similar stories. Emery's second wife, Irene, died in the castle on his birthday in 1907. As a result, the castle was closed and sat vacant until it was destroyed by fire in 1956. This photograph shows the castle before the ballroom extension was added.

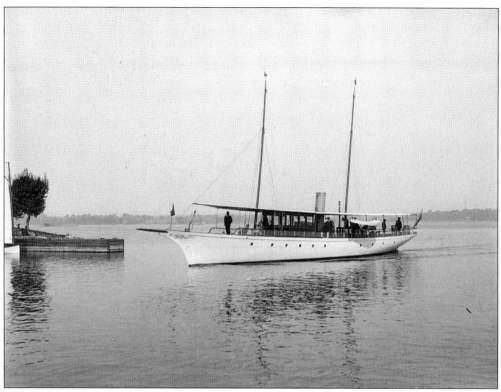

Charles Emery's Herreshoff yacht *Nina* is shown near Round Island. Herreshoff yachts were very popular on the St. Lawrence River.

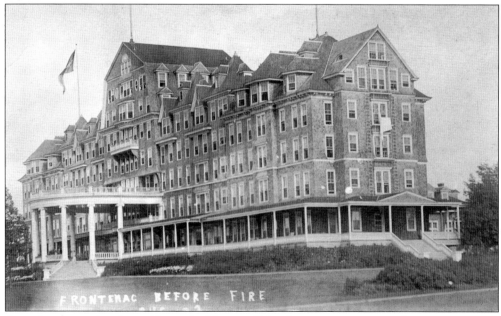

As national attention focused in on the Thousand Islands as a summer retreat, fancy resorts sprang up in no time. The New Frontenac Hotel was located on Round Island. Charles Emery was the largest stockholder. It was designed to be the greatest hotel in the Thousand Islands.

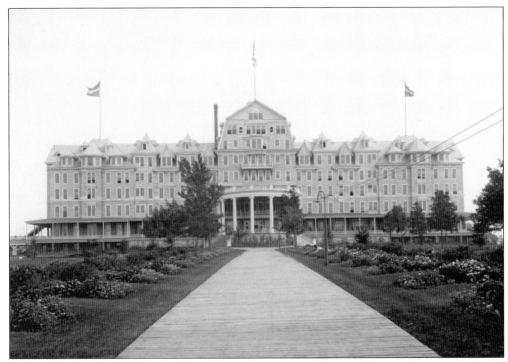

The New Frontenac Hotel had a nine-hole golf course and electric lighting. Among the hotel's most distinguished guests were Pres. William Howard Taft and Thomas Edison.

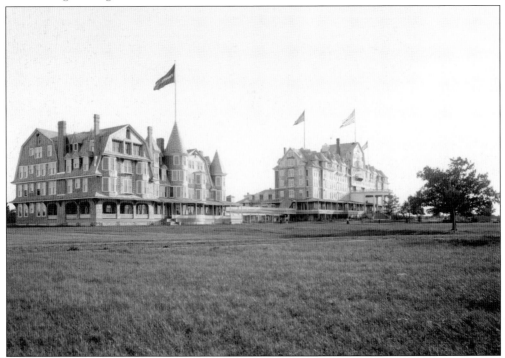

In 1901, an annex was added to the New Frontenac Hotel to accommodate more guests. The hotel burned on August 23, 1911, due to an unattended cigarette.

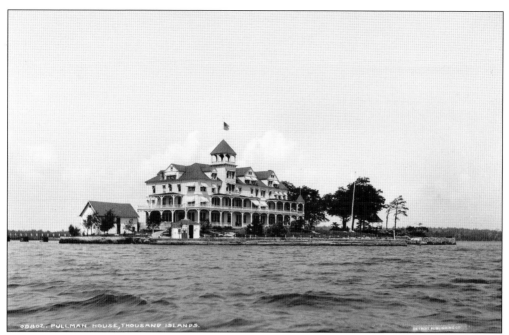

The Pullman House was built in 1890 on Pullman Island. This three-story hotel was named after George Pullman. Like many other hotels in the Thousand Islands, it burned down.

The Murray Hill was built in 1895 on Murray Island. It was four stories and had a wraparound porch. The hotel closed in 1915 and fell into disrepair.

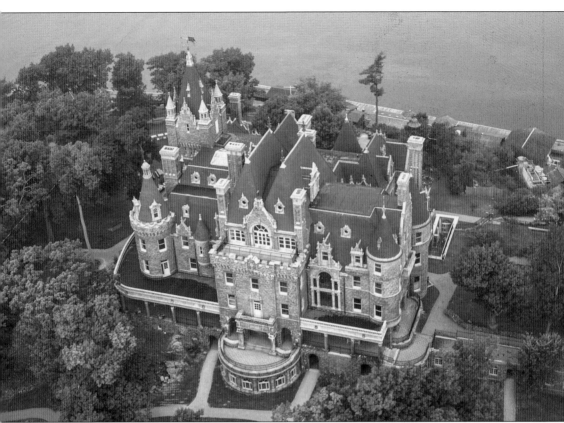

In 1900, George C. Boldt built his six-story Rhineland castle on Heart Island in Alexandria Bay, New York. Boldt was the proprietor of the Waldorf Astoria Hotel in New York City. The castle was meant to be a symbol of his love for his wife, Louise. A majority of the granite was from the Oak Island Quarry. Work stopped suddenly in 1904 when Louise passed away. According to legend, Boldt never stepped foot on the island again. (Courtesy of Ian Coristine, 1000IslandsPhotoArt.com.)

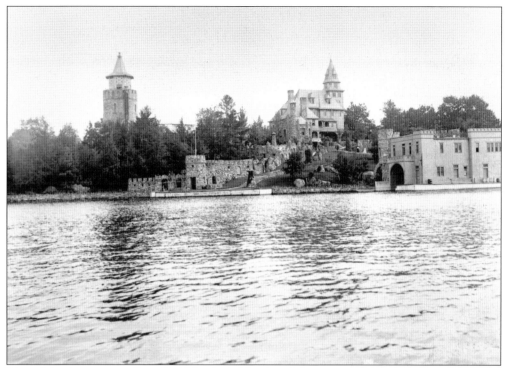

Heart Island was originally called Hemlock Island and then Hart Island. George Boldt bought the property from congressman E.K. Hart's estate in 1895 and replaced the original cottage with the castle presently there.

Boldt's influence can still be enjoyed at the Thousand Islands Club. Some things that he was well known for, like "the customer is always right" and the Thousand Island dressing he helped popularize, still prevail today.

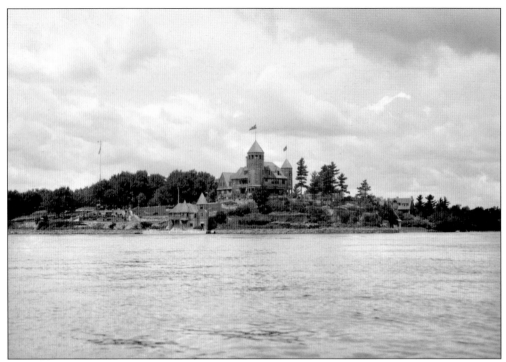

Hopewell Hall was built on Wellesley Island in 1890 for William Browning. Browning made his fortune selling Civil War uniforms. This property was later sold to George Boldt.

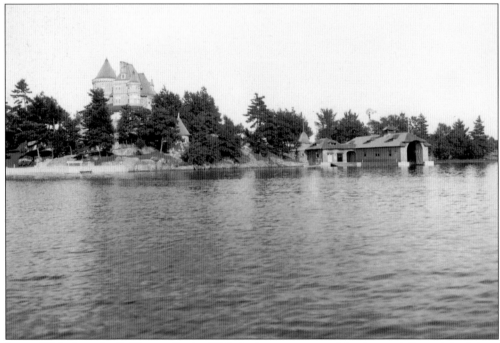

James W. Jackson built Keewaydin in 1893. Jackson was a stockbroker and financial advisor. In 1961, the State of New York tore down the original mansion and turned the site into the Keewaydin State Park.

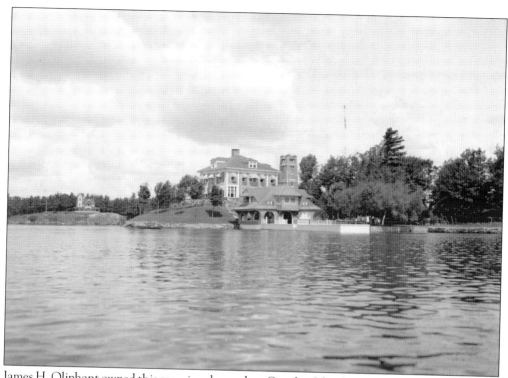

James H. Oliphant owned this mansion, located on Comfort Island. Oliphant and his family lived in New York City and spent their summers in the Thousand Islands.

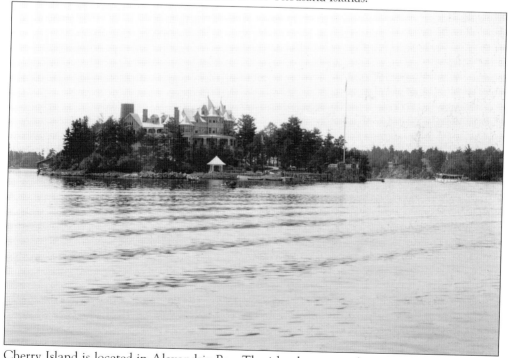

Cherry Island is located in Alexandria Bay. The island was once home to three of the most impressive mansions on the river—Casa Blanca, Bellora, and Olympia.

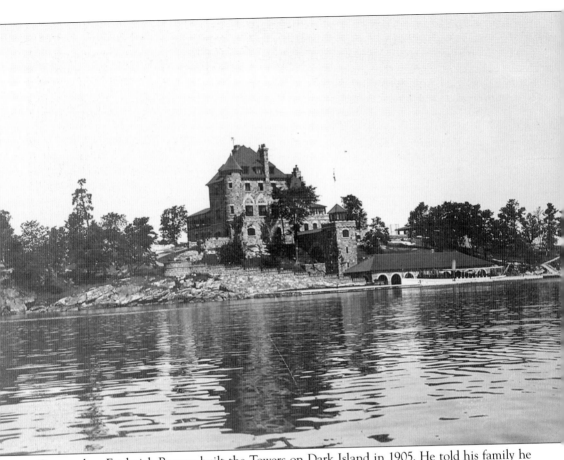

Commodore Frederick Bourne built the Towers on Dark Island in 1905. He told his family he was building a hunting lodge. When they showed up at Dark Island and saw a castle, designed by Ernest Flagg, and complete with dungeons and secret passageways, they were completely surprised. A majority of the stone for the castle was from the Oak Island Quarry. (Courtesy of *Singer Castle Revisited*.)

Frederick G. Bourne was the fifth president of the Singer Manufacturing Company. He also served as commodore of the New York Yacht Club from 1903 to 1905. (Courtesy of *Singer Castle Revisited*.)

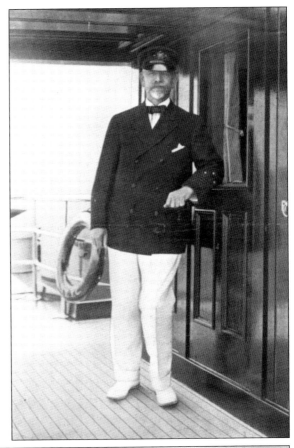

Commodore Bourne's yacht *Dark Island* is shown below. She was built in 1912 and was capable of 20 miles per hour. (Courtesy of *Singer Castle Revisited*.)

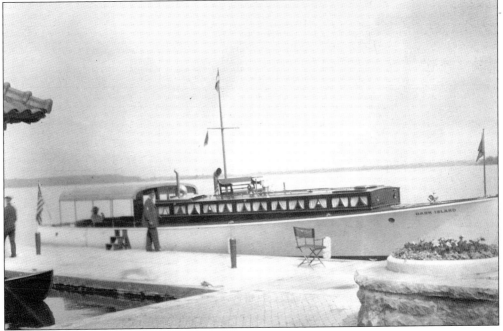

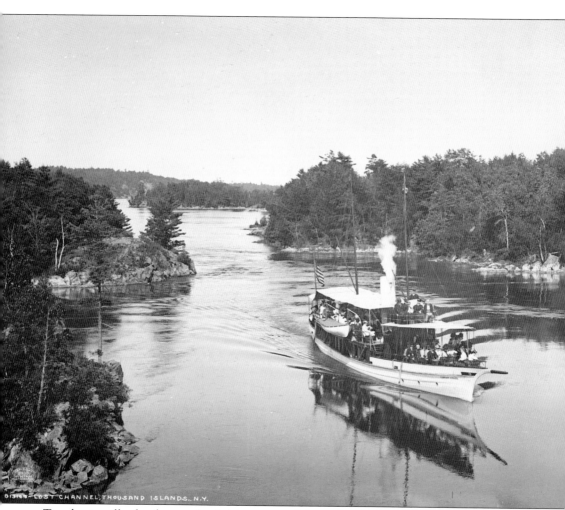

LOST CHANNEL, THOUSAND ISLANDS, N.Y.

Tour boats still take thousands of visitors up and down the St. Lawrence River every summer. Countless tales are told about islands, mansions, and shoals. Nothing is better than a scenic boat ride and a good story; however, one must be able to decipher what is actual history and what makes for a good legend.

Three

THE LYON FAMILY

Few families embody the St. Lawrence River like the Lyon family of Ogdensburg and Oak Island. Other prominent Thousand Islands families like Bourne, Boldt, and Pullman had their roots and made their fortunes in the great cities to the south. But the Lyons were homegrown. They had the waters of the St. Lawrence River flowing through their veins.

John Lyon, a hero of the Revolution from Morristown, New Jersey, arrived in Upstate New York in 1796. Along with a small group of fellow war veterans, John helped found the city of Ogdensburg.

John's great-grandson David Howard Lyon would also serve his country in war. In 1861, not long after hostilities broke out between the Union and the newly formed Confederacy, David, just 16, enlisted in the 60th New York Volunteers. He participated in over 25 battles. David married Ella Maria Potter soon after the war on June 20, 1865. Their only child was born May 14, 1869. They named him Charles Potter Lyon.

After the war, David went into the lumber and milling business. He was a dour, hardworking, fingers-to-the-grindstone Yankee who worked six days a week, fourteen hours a day. David had not only exceptional business acumen but also an ingenious mind for invention. He designed a water purification system that allowed ships with steam engines to run with far greater efficiency. In the late 1880s, David founded the Canadian Pacific Car & Passenger Transfer Company, and his fortune was made.

Captain Lyon owned many fine boats, including the *Outing* and the *Carmencita*. He and his family spent much of their summers on these boats as they toured up and down the St. Lawrence River. In 1898, David bought land on Oak Island in Chippewa Bay. A few years later, he built a large wooden house on a spectacular point of land with magnificent views of the river. It would be his summer home for the rest of his long and productive life. David died on September 26, 1928.

Charles "Charlie" Lyon was not a chip off the old block. Charlie was neither dour nor hardworking. He enjoyed a good time. The only son of a well-to-do gentleman, Charlie lived an exciting and carefree life. He traveled widely to the far corners of the globe. And when he finally tied the knot, at the ripe old age of 43, he married a lovely young woman 23 years his junior.

Charlie shared two passions with his father. The first was a love of the St. Lawrence River, especially the Thousand Islands. And the second was a passion for boats. In the years ahead, Charlie Lyon would be responsible for building some of the finest commuters and runabouts to ever grace the waters of the St. Lawrence River.

The Lyon family left an indelible mark on the Thousand Islands. The legacy David and Charlie built is still alive and well today.

David Howard Lyon was born on October 21, 1845. During the Civil War, he served as a drummer boy, taking part in 26 engagements and sustaining one wound. After the war, David attended Eastman's Business College. In 1866, he and his father, Charles, "the Roaring Lyon," became partners in a lumber and sawmill business.

The Lyons were one of Ogdensburg's first families. John Lyon Sr. was among the first settlers who helped develop a grant of land in 1796 that became known as Ogdensburg. David and his wife, Ella, had this photograph taken on their honeymoon in Niagara Falls.

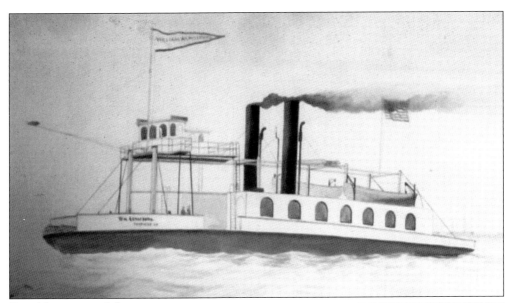

David Lyon started the Canadian Pacific Car & Passenger Transfer Company in 1888. This company linked the Canadian Pacific and New York Central Railroad lines. Train cars were transported across the St. Lawrence River on barges. A watercolor of the *William Armstrong* is shown here.

David's only son, Charles Potter Lyon, was born May 14, 1869, in Ogdensburg, New York. He attended Dr. Holbrook's Military School and graduated from Brockville Business College.

In 1882, David Lyon created a water purification system. By 1893, he had a Royal Patent from the United Kingdom. This system removed impurities from water and made steam boilers more efficient. The Hanna Corporation was responsible for distribution.

The Lyons regularly enjoyed boating on the St. Lawrence River. As prominent locals began their quest for island territory, David Lyon set his eyes on Oak Island. Oak is the seventh-largest island in the Thousand Islands.

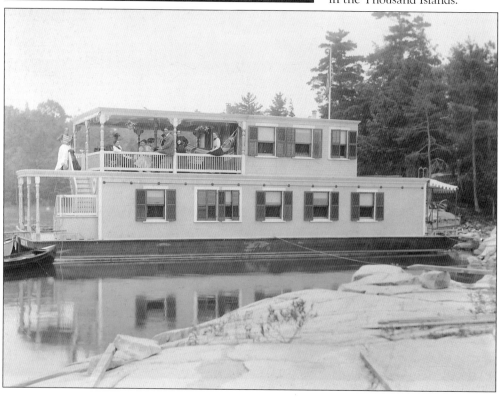

Captain Lyon's 60-foot steam yacht *Outing* is moored in the bay at the foot of Oak Island. David was one of the founding members of the Chippewa Yacht Club in 1895.

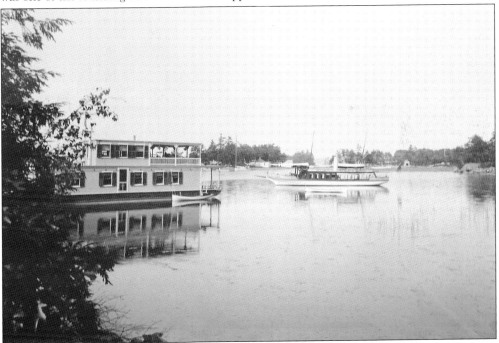

Captain Lyon bought 10 acres of land surrounding the bay on Oak Island in 1898 for $750. He named this area of land Lookout, which was a tribute to his Civil War days. The Battle of Lookout Mountain was a key victory for the North.

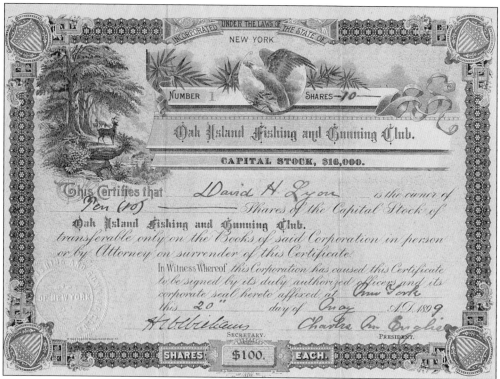

Oak Island had an active fishing and hunting club. The first house on the island was the hunting lodge built by Boldt, Bourne, Englis, and Lyon. It has been rumored that the men drank and gambled more than they hunted.

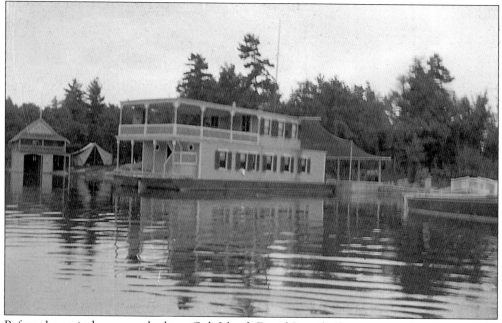

Before the main house was built on Oak Island, David Lyon built a two-story boathouse and a pavilion. The top deck of the houseboat was also expanded.

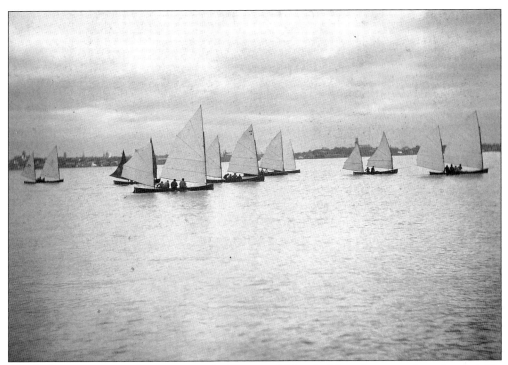

Charlie Lyon was an avid sail racer in the Thousand Islands. These boats are bat-winged skiffs. Charlie's boat *Boss* is on the right.

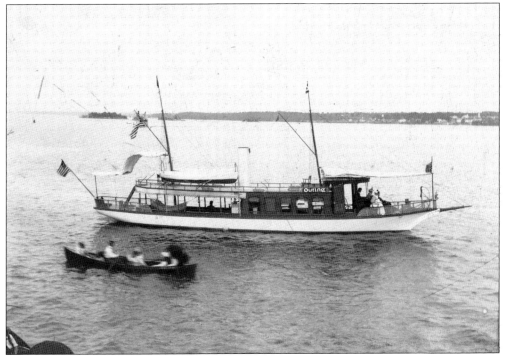

The *Outing* was the first of the Lyon families' great boats. She was built in 1892 and had a triple-expansion engine that was used to convey the Lyons from Ogdensburg to Oak Island.

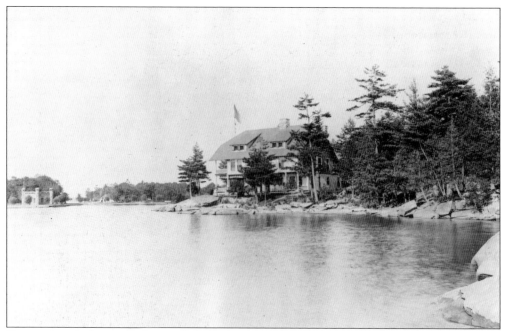

Captain Lyon's three-story house on Oak Island was completed in 1907. It took two years to build and cost $5,000. Four fireplaces of stone quarried on Oak Island open into one chimney. The interior of the house is of hard pine, with walls covered with burlap and the studding varnished. It is reported that 100 gallons of varnish were used.

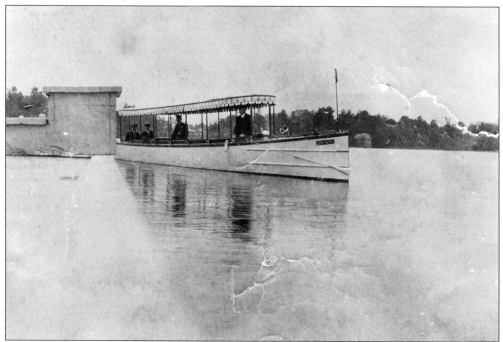

Joseph Leyare built Captain Lyon's 55-foot *Carmencita* in Ogdensburg. She had a six-cylinder H.J. Leighton engine, and when launched in 1907, she was the fastest kerosene-powered boat in the Thousand Islands. *Carmencita* was capable of speeds of 20 miles per hour.

David Lyon was also an active member of the New York Yacht Club, the Pontiac Club, the Thousand Islands Yacht Club, and the Frontenac Yacht Club. Captain Lyon was the founder and president of the Canadian Pacific Car & Passenger Transfer Company.

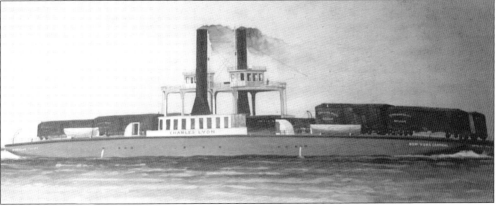

In 1908, the steel steamer *Charles Lyon* became the staple vessel for the Canadian Pacific Car & Passenger Transfer Company. She was 280 feet, could carry 14 train cars at a time, and was capable of transporting 500 cars per day. David Lyon named this vessel after his father.

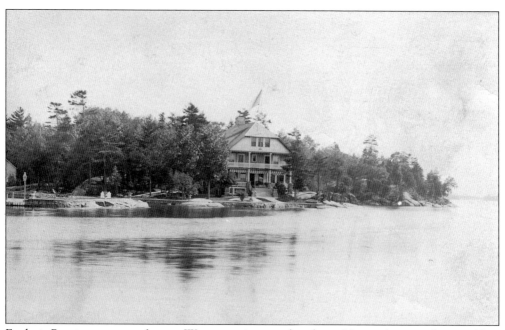

Frederic Remington was a famous Western painter and sculptor. He was born in Canton, New York, and was a friend and neighbor of the Lyons. Remington lived on Ingleneuk Island and frequently visited Lookout.

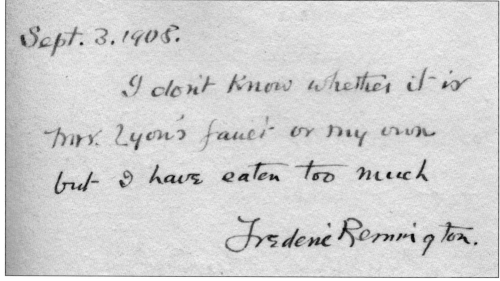

On September 3, 1908, Remington signed the following in Lyon's guest book: "I don't know whether it is Mrs. Lyon's fault or my own but I have eaten too much." The Frederic Remington Art Museum is located in Ogdensburg, New York.

The Lyon's gaff-rigged sloop is shown in Chippewa Bay. The shadow of Dark Island can be seen in the distance. The Lyons had a sailing trophy, called the Lyon Cup, that was put up every year in Chippewa Bay.

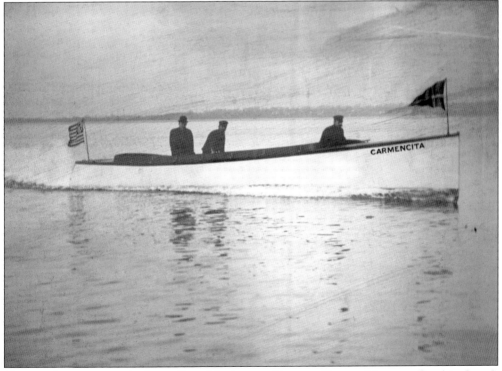

Carmencita was named after a Spanish dancer, Carmen Dauset Moreno. Captain Lyon's launch served as the flagship of the Chippewa Yacht Club. This boat was one of his greatest nautical accomplishments.

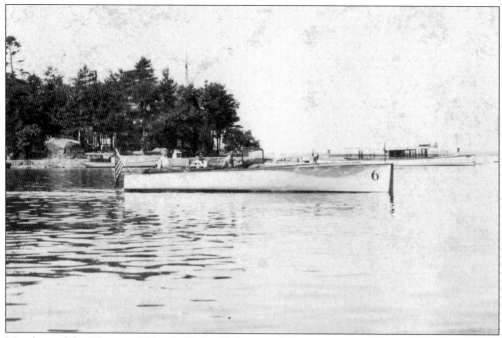

Members of the Thousand Islands Yacht Club wanted to compete in a set of races that required all the boats and motors to be identical. Joseph Leyare built these boats in Ogdensburg from 1909 to 1912. They are known as Number Boats. David Lyon's No. 6 *Betty* is shown here in 1910.

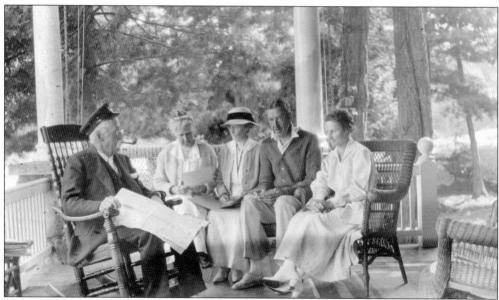

The Lyon family is shown on the porch at Oak Island. Charlie has just returned from the Battle Creek Sanitarium to surprise his family with his new wife. He met Helen Griffin in the hydrotherapy department at the sanitarium, and they eloped in the spring of 1912. Charlie and Helen are seated on the right.

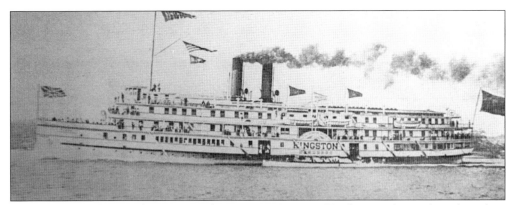

Carmencita can be seen here racing the steamer *Kingston*. Her bow is almost directly in line with the second smokestack. *Kingston* was one of the major vessels in the Canadian fleet of the Richelieu & Ontario Navigation Company.

In 1922, the Canadian Pacific Car & Passenger Transfer Company transported $100,000,000 worth of silk across the river at Ogdensburg. The connection at Ogdensburg was the fastest way to get goods from Asia to New York City. This photograph of Captain Lyon was on the front page of the *Ogdensburg Advance*.

David Lyon passed away on September 26, 1928. The bulk of his estate was left to his wife, Ella; son, Charlie; and daughter-in-law, Helen. Captain Lyon's will left donations of $18,000 to United Helpers and the Ogdensburg Orphanage. It also left a donation of $9,000 to the Presbyterian church he regularly attended.

The car ferry *Charles Lyon* is pictured. She served as the main vessel for the transfer company for over 20 years. She was equipped with twin 800-horsepowered engines and could operate 365 days a year.

Car Ferry Company Is Purchased By the CPR. From The Lyon Estate

Business Established by Late Capt. D. H. Lyon More Than Half Century Ago Forms Important Link With Canada.

Charlie cashed out on the Canadian Pacific Car & Passenger Transfer Company when his father died. The business was sold in 1929 to the Canadian Pacific Railway. This photograph shows a newspaper clipping from the *Ogdensburg Advance*.

Captain Lyon had homes in Ogdensburg, New York City, St. Petersburg, Florida, and the Isle of Pines (now Isla de la Juventud), Cuba. When Ella Lyon passed away in 1930, her will left half of her estate to Charlie, and the other half to her daughter-in-law, Helen. Ella knew Helen would be more frugal with the inheritance.

Charlie Lyon is pictured sailing his boat the *Indian*. He would do everything he could to step out of the shadows of his father's legacy and create one of his own.

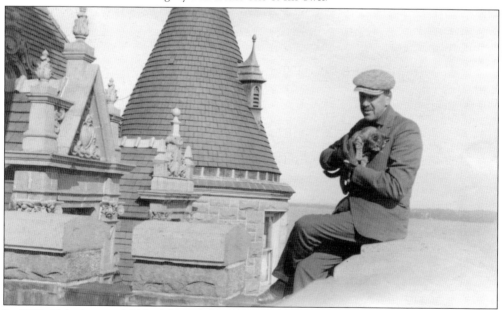

In 1930, Helen's sister Mildred Betts became a widow. As she planned to remarry, her fiancé met her with strict demands, "I will marry you, but I won't take your child." Charlie and Helen gladly stepped in and raised Janine Betts. Charlie is shown here petting a cat on the top balcony of Boldt Castle.

Four

FINESSE

During the Roaring Twenties, the economy boomed and money spilled out of men's wallets like water over Niagara. It felt like people had cash to burn. Discretionary income became part of the American vernacular. The consumer society blossomed and bloomed.

The small hamlet of Alexandria Bay along the St. Lawrence River provides a perfect paradigm. In the waning years of the 19th century, Alexandria Bay supported two small ragtag boatbuilding shops. By 1920, things had changed dramatically. The arrival of the big moneymen from Boston and New York, Pittsburgh and Chicago caused the boatbuilding business to boom. Lucious Britton, Alfred Lee, Fred Adams, Fitz Hunt, Dan Duclon, George and Bert Hutchinson, Bernie Fitzgerald, and others all earned handsome incomes designing and building boats for the opulent set who summered in the Thousand Islands.

Of course, boom times never last, and the crash of 1929 forced the closure of all but the finest of Alexandria Bay's boat shops. Arguably, the best of the best was Fitzgerald & Lee, an outfit that originally sold and serviced Gar Wood boats but later began designing and building boats of its own.

So, it was no surprise when Charlie Lyon went to see Bernie Fitzgerald in the summer of 1932 to discuss the purchase of a custom-designed river cruiser. The result of that meeting was the sophisticated and incomparable commuter *Finesse*. Designed by John L. Hacker for Fitzgerald & Lee, *Finesse* was launched in June 1933. She was made of solid mahogany and trimmed with chrome. The boat cost close to $20,000 to design and build, and she was powered by a 330-horsepower Scripps V-12 engine. With that level of power under the hood, *Finesse* could rip up and down the St. Lawrence River at over 35 miles per hour.

That summer of 1933, *Finesse* was the star of the St. Lawrence River. Everywhere Charlie and Helen went, people commented on its elegant lines and graceful beauty.

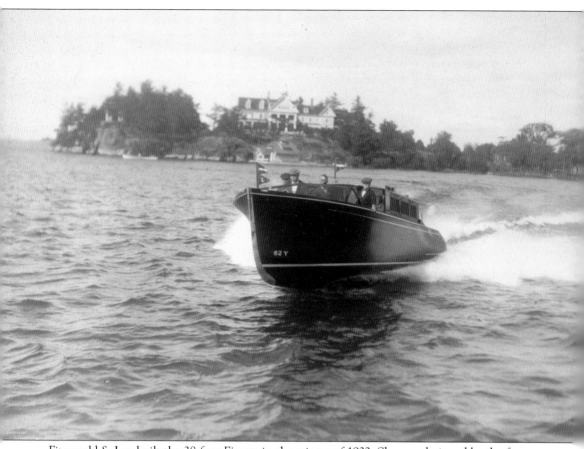

Fitzgerald & Lee built the 38-foot *Finesse* in the winter of 1932. She was designed by the famous naval architect John L. Hacker and was capable of speeds of 35 miles per hour. Charlie Lyon, following his father's lead, had his first taste of a custom-built boat and loved the result. Bonnie Castle, in Alexandria Bay, can be seen in the background.

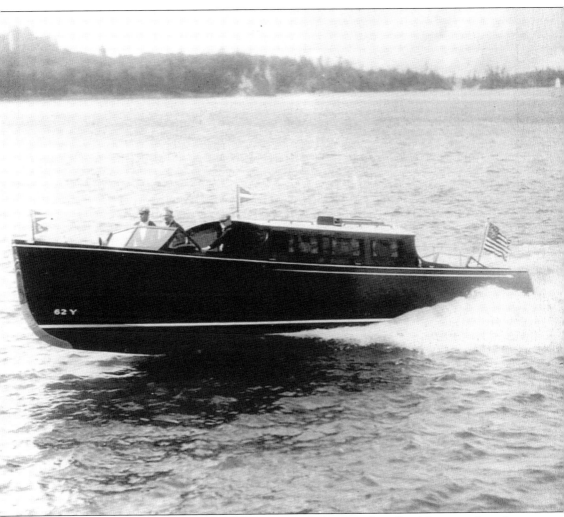

Finesse was built during the Great Depression and quickly became the talk of the river when she was launched in the spring of 1933. The custom commuter brought a lot of attention to Fitzgerald & Lee, John Hacker, and Charlie Lyon up and down the St. Lawrence River. Note the Chippewa Yacht Club burgees and the "L" for Lyon. Boldt Castle can be seen in the background. (Courtesy of the Antique Boat Museum, Clayton, New York.)

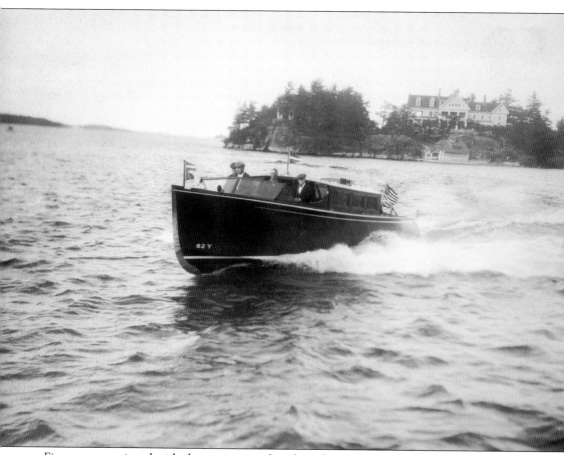

Finesse was equipped with the most up-to-date furnishings for comfort and safety. She had an open forward helm, a large enclosed cabin, and an aft cockpit for passengers to move around and enjoy. *Finesse* was designed to transport Charlie and his guests around the Thousand Islands and could hold 200 gallons of gasoline.

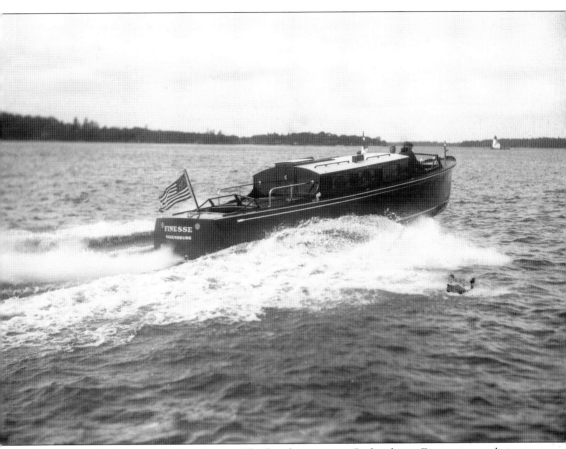

The name on the back of the boat boasts Charlie's hometown, Ogdensburg. *Finesse* is seen here speeding out of Alexandria Bay. Off the bow of the boat, one can see Sunken Rock Lighthouse. This was Charlie Lyon's first attempt at a custom commuter.

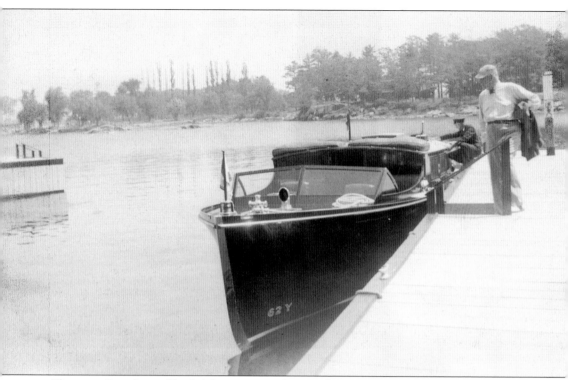

Chauncey Burtch was Charlie's boat captain; he went by "Cap" and was a trusted man who knew the Thousand Islands very well. Cap was from Alexandria Bay but would regularly stay the night on Oak Island in case he was needed. He was Charlie's caretaker and boatman for over 30 years. *Finesse* is pictured here docked at Oak Island in 1935. Charlie Lyon is standing in the foreground, and Joe Smith is kneeling in the background.

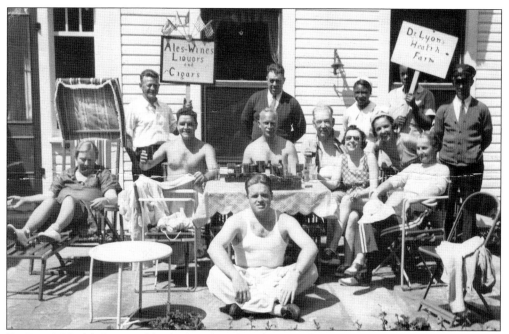

Dr. Lyon's Health Farm—Charlie loved to show his friends a good time on the river. His boat captain and first mate, Chauncey Burtch (rear center) and Joe Smith (far right), can be seen in their uniforms. Charlie's custom commuter ensured that there would be a few more parties on Oak Island.

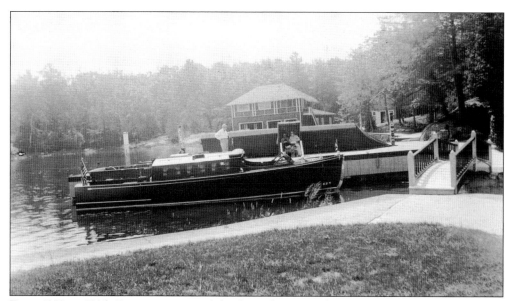

From 1933 to 1935, *Finesse* was one of the finest boats on the St. Lawrence River. She could accommodate 22 passengers and had a cushion on the roof that provided a bird's-eye view.

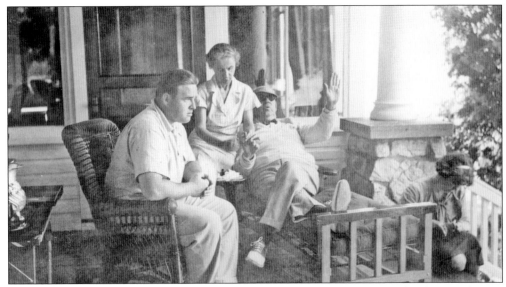

Charlie was used to having things done for him. In this picture, he is getting his nails cut by his wife, Helen. To his right is his soon-to-be brother-in-law Judd Renz and to his left is his sister-in-law Margaret Griffin.

One of the many sailboats Charlie owned is pictured here in the bay on Oak Island. The boat was called *Dove* and is shown without her jib.

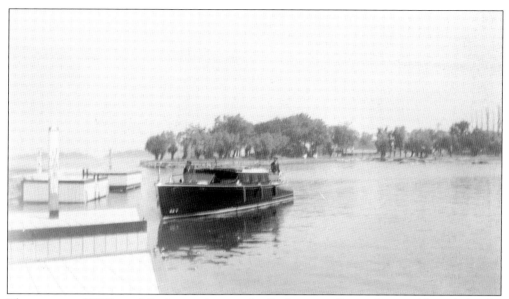

The summer of 1935 was full of excursions on the St. Lawrence River. Cap would regularly take the Lyons and their guests on tours throughout the Thousand Islands.

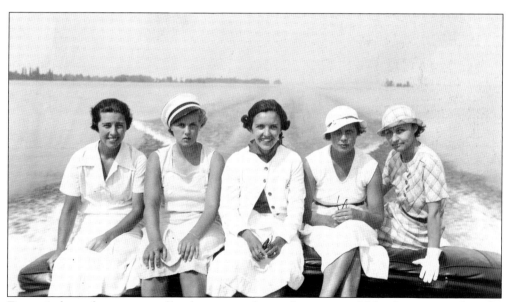

Finesse is shown here on one of her last cruises during that summer. Helen Lyon is seated on the right with gloves on. Her youngest sister, Jeanne, is in the middle.

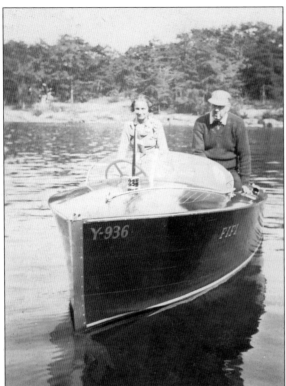

By the end of the summer, Charlie had his next boat picked out. As he discussed the plans for *Vamoose* with his friend Edward Madill, he said, "If I can ever get rid of that thing, this is what I'm going to build." That thing was *Finesse*, and she burned two weeks later.

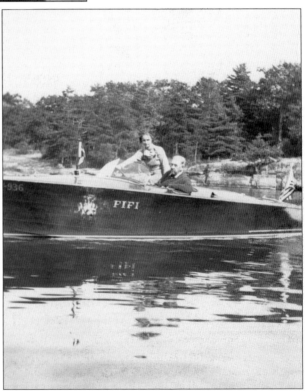

This is one of Fitzgerald & Lee's Gar Wood runabouts. Charlie named this Gar Wood after his niece Janine Betts, who went by "Fifi."

Captured on Sunday, August 25, 1935, this is one of the last photographs ever taken of *Finesse*. The Lyons and their guests are at Rob Roy Island, preparing to watch the motorboat races in Alexandria Bay. That is Charlie in all white. The Cedar Island group is in the background.

14 Persons Rescued As Lyon's Cabin Cruiser Burns On St. Lawrence

Mr. and Mrs. Charles P. Lyon and Members of Party Aboard the "Finesse" Taken off Burning Craft Near Boldt's Island at Alexandria Bay — Burns to Hull plosion—Boat Burned to Hull

This newspaper clipping is from the *Ogdensburg Advance*, dated Monday, August 26, 1935. Fourteen people were pulled off the burning craft near Boldt Castle. *Finesse* caught fire while idling around the Alexandria Bay racecourse. There was a loud blast when the Scripps motor overheated, and flames came pouring out of the engine compartment.

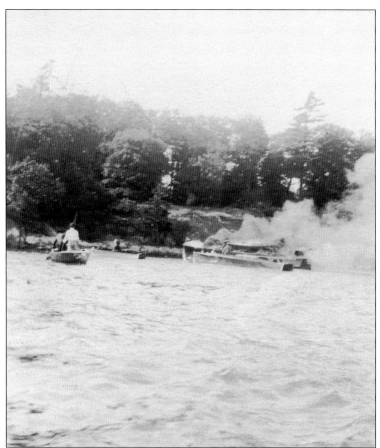

In no time, Jim Alker and Jim Rendall were there with two boats to help get the Lyons and their guests off the burning craft. The women and children were taken off in the first boat, and the men were placed in the second. Charlie Lyon said, "*Finesse* est finis" as he watched his boat burn to the waterline off Harbor Island near Boldt Castle.

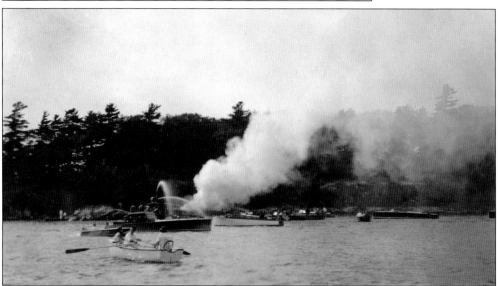

When the fire was finally put out, *Finesse* was a pile of twisted steel. Fitzgerald & Lee would use what it could for parts. Bernie Fitzgerald, of Fitzgerald & Lee, provided Charlie and his guests transportation back to Oak Island.

Five

VAMOOSE

Less than two weeks after the *Finesse* burned to the waterline, Charlie Lyon was back at Fitzgerald & Lee. He spent hours with Bernie Fitzgerald and Alfred Lee discussing what to build next. By the end of the meeting, it was decided John L. Hacker, the famed naval architect and the man who had designed *Finesse*, would once again be contracted to design Charlie's new commuter. Contracts were written, drawings drafted, and modifications added. Charlie's demands were simple; he wanted a bigger, faster commuter—bigger and faster than *Finesse*. He wanted a boat at least 44 feet in length.

In the late spring of 1936, the new boat was launched. Across the glistening transom, it read "*Vamoose*, Oak Island." The word *vamoose* means to depart rapidly, with great haste. Charlie Lyon's new mahogany-and-chrome commuter could do that and more. The long, lean beauty could reach speeds in excess of 40 miles an hour with the raw power of her twin 200-horsepower Sterling engines. The owner and designer may have not agreed on everything, but the final result was a boat of exceptional power and grace.

Vamoose moved Charlie and his family and friends swiftly and comfortably up and down the river throughout the summer of 1936. The Lyon family once again had the most impressive commuter in the Thousand Islands and Charlie's moniker, the "King of the St. Lawrence," was secure.

But even before the final modifications were complete on the *Vamoose*, other well-heeled summer residents were busy pursuing their own watery dreams. Charlie's competitive brethren up and down the Thousand Islands were not sitting idly by. They all had snazzy cruisers of their own under construction. Sure enough, when Alfred Bourne, son of Commodore Frederick Bourne, launched his flamboyant runabout *Messenger* late in the summer of 1937, Charlie felt he had been outdone. The feeling resonated again in 1939 when George Boldt's son-in-law, Nils Johanesson, hired John L. Hacker to design a triple cockpit runabout. Christened *Skol*, she was one of Fitzgerald & Lee's most impressive boats. *Skol* and *Messenger*, much to Charlie Lyon's dismay, turned out to be the talk of the Thousand Islands.

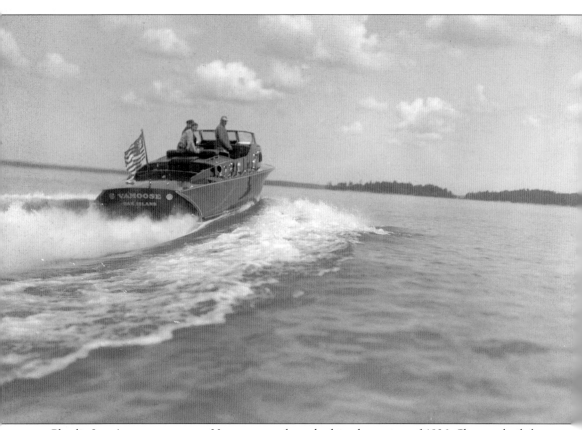

Charlie Lyon's new commuter, *Vamoose*, was launched in the spring of 1936. She was built by Fitzgerald & Lee and designed by John L. Hacker. In October of that year, she was featured in a write-up in *Motor Boat* magazine, which brought incredible attention to both Fitzgerald & Lee and John Hacker. The Cedar Island group is to the right.

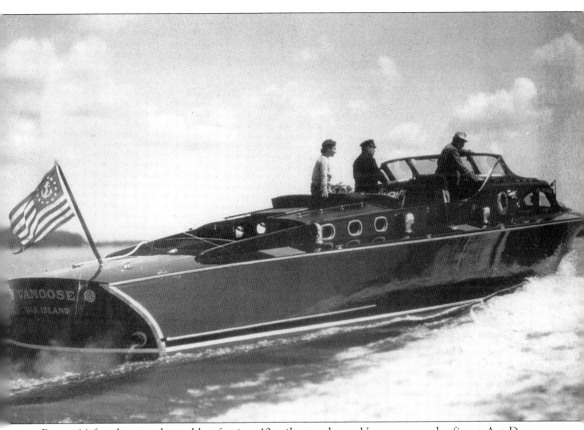

Being 44 feet long and capable of going 40 miles per hour, *Vamoose* was the finest Art Deco commuter on the St. Lawrence River. The sheer size of this boat was breathtaking. Those that know of *Vamoose* regard her as Fitzgerald & Lee's flagship. She is often referred to as the company's most magnificent vessel.

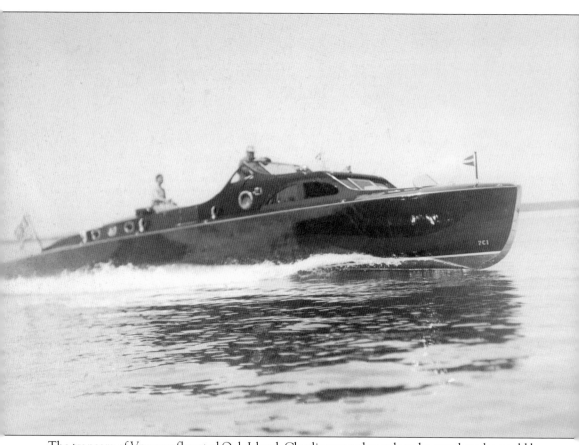

The transom of *Vamoose* flaunted Oak Island. Charlie wanted people to know where he could be found as he sped off into the distance. These photographs were submitted to various magazines to generate publicity for both Fitzgerald & Lee and Hacker. Prominent locals took notice, and soon, Hacker would become the premier designer for the Thousand Islands.

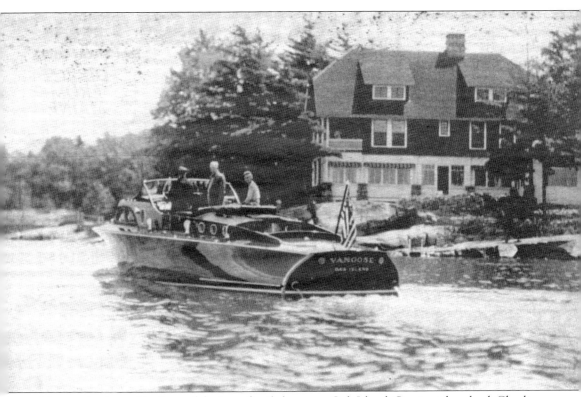

Vamoose is pictured in front of the Lyon family home on Oak Island. Cap is at the wheel; Charlie and Helen are on board for the photo shoot. Charlie had seen an advertisement for one of John Hacker's commuters in *Motor Boat* magazine in 1935. He knew instantly he had to have one of his own.

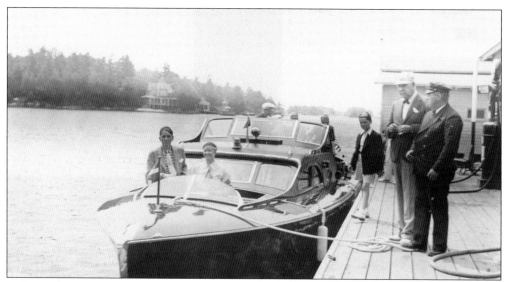

Vamoose is pictured here at Fitzgerald & Lee's gas dock in Alexandria Bay. Chauncey Burtch and Charlie Lyon can be seen on the dock.

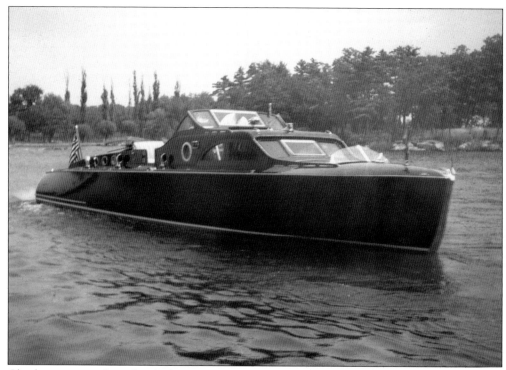

Charlie was very pleased with the attention *Vamoose* brought him. Canadian Customs officials were chief among the impressed. They would see *Vamoose* speed by and say, "There goes Charlie Lyon, the king of the St. Lawrence."

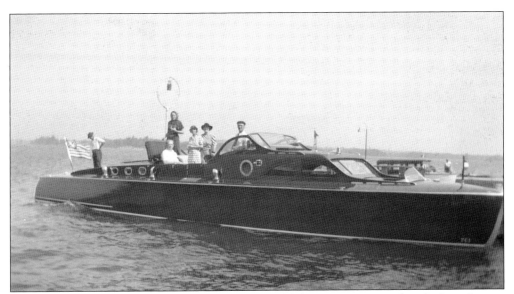

Charlie pinched the name *Vamoose* from William Randolph Hearst's steam yacht, which was known as the fastest boat in the world in the 1890s. The word *vamoose* means to leave in a hurry.

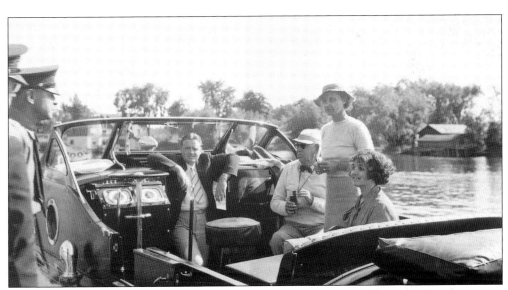

Cap would regularly pick Charlie's guests up in Ogdensburg and drive them the 30 miles upriver to Oak Island. *Vamoose* could accommodate close to 30 passengers.

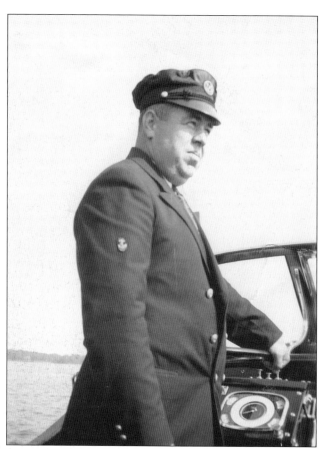

Chauncey Burtch was in charge of a lot on Oak Island. He was the cook, the bartender, as well as the boatman. He and Bill Aiken were the brains behind everything on the island.

Cap's first mate Joe Smith is shown below in the stern of *Vamoose*. *Vamoose* was powered with twin 200-horsepower Sterling engines.

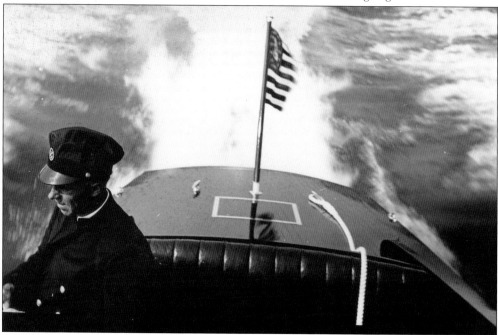

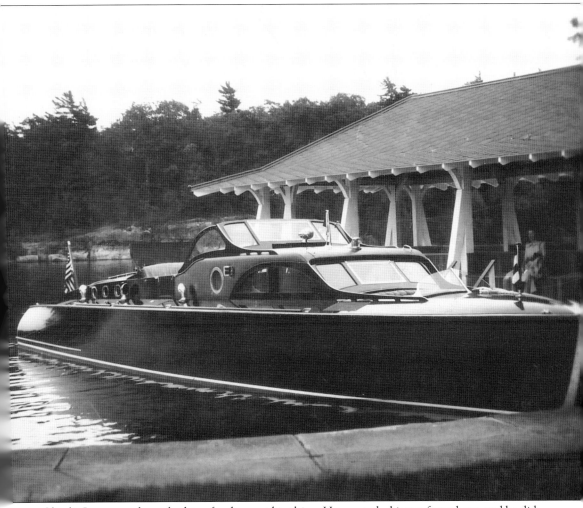

Charlie Lyon was always looking for the next big thing. He wanted a bigger, faster boat, and he did not like the original front windshield or cabin. These issues, along with the engine overheating, resulted in Charlie's unsuccessful attempt to sell *Vamoose* at the end of that first season. When she did not sell, the decision was made to remodel her. Charlie contacted Hacker and had new designs drawn. Fitzgerald & Lee altered the cabin so passengers could walk through to the front cockpit.

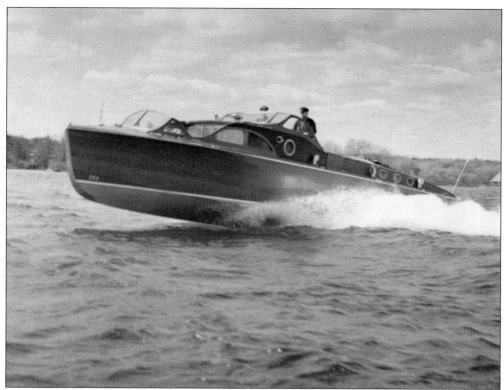

The new windshield added a beautiful touch to the swooping lines of *Vamoose*. The modifications were technically challenging designs, and Fitzgerald & Lee lived up to its reputation as the best of the best.

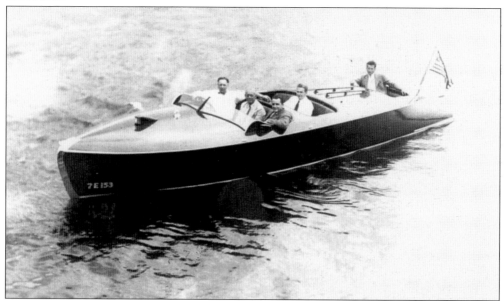

When Bourne's Art Deco 28-foot runabout *Messenger* was launched, she was the talk of the St. Lawrence River. *Messenger*'s lines were sleek, and the boat was fast and quickly became a Thousand Islands classic. (Courtesy of the Antique Boat Museum.)

Vamoose had a pop-up seat on top of the engine box to accommodate a potential overflow of passengers. The rumble seat, as it was called, provided a spectacular view for Charlie and his guests to enjoy.

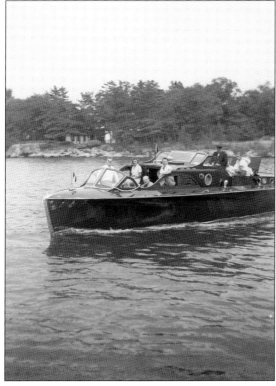

Charlie flew an L flag for Lyon, just like he had on *Finesse* and just like his father flew an L on *Carmencita*. The new forward cockpit could comfortably fit eight people.

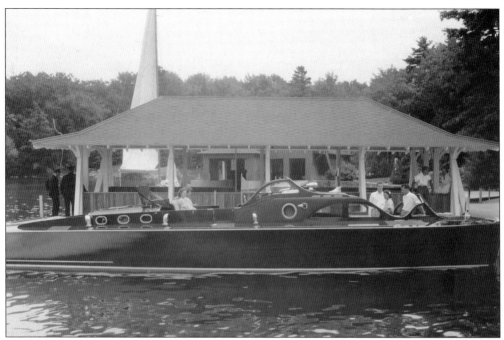

Charlie Lyon had a private 500-gallon gas dock on Oak Island. *Vamoose* is shown tied to the Lyon family docks. The 44-foot Art Deco commuter was the pride of Chippewa Bay.

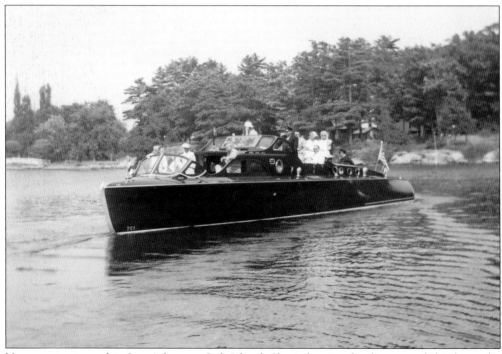

Vamoose is pictured in Lyon's bay on Oak Island. She is leaving for dinner and drinks at the Thousand Islands Club.

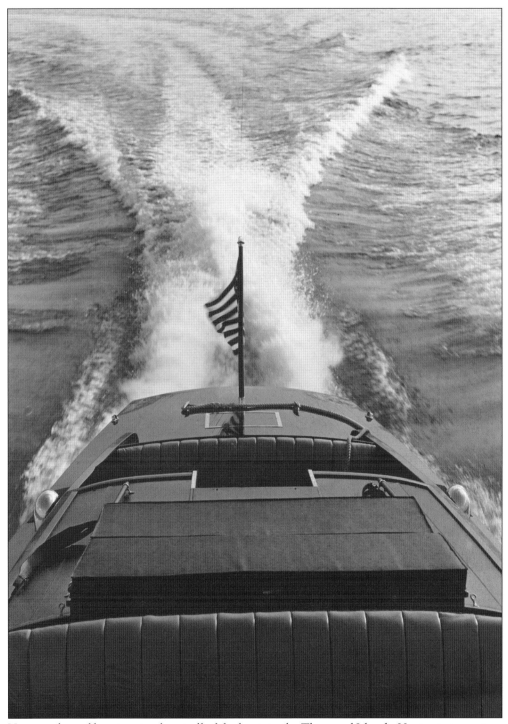

Vamoose showed her stern to almost all of the boats in the Thousand Islands. Having twin engines made her one of the most powerful boats on the St. Lawrence River at that time. Charlie would use his commuter to convey his guests to and from his 500-acre Oak Island and to both sides of the St. Lawrence River.

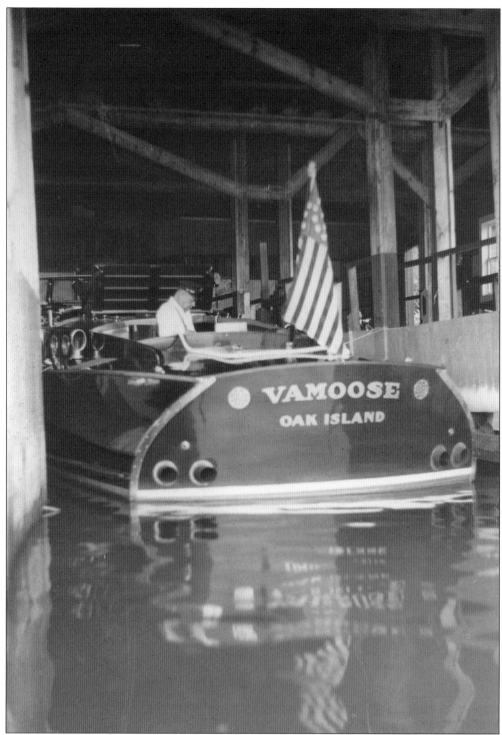

One of the things that is interesting about this photograph is there are four exhaust pipes, instead of the original two. *Vamoose* is pictured here in her slip in the boathouse on Oak Island. One can clearly see Cap working in the engine room.

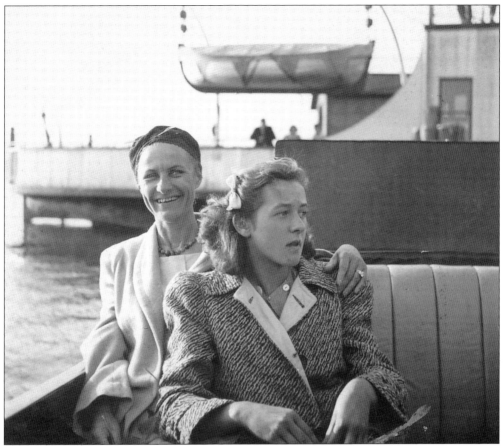

Charlie often referred to himself as a "Tom Cat" and referred to his wife as a "Tommy Cat." Charlie thought it was so funny, he started calling Helen by the name Tommy, and the nickname stuck. Tommy and Fifi are pictured here in *Vamoose*.

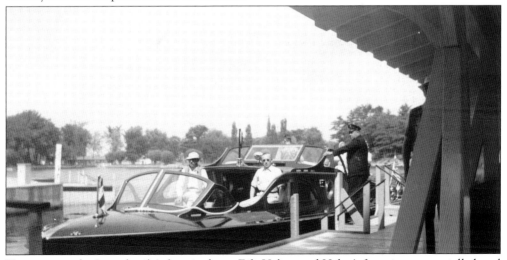

Vamoose was the Lyon family's favorite boat. Fifi, Helen, and Helen's four sisters especially loved it. This may be part of the reason why Charlie was willing to make the changes he did.

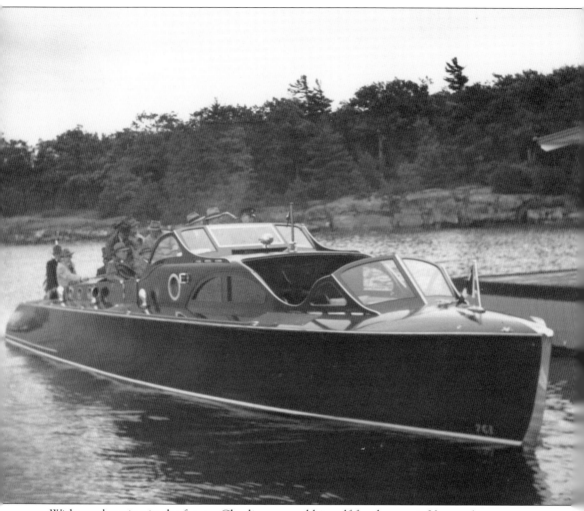

With war looming in the future, Charlie prepared himself for the worst. *Vamoose's* summers on the river were numbered. Her fate would be predetermined. Shown here on one of her autumn cruises, she would soon be donated to the war effort.

Six

WORLD WAR II

In the late 1930s, Americans did an excellent job pretending peace would prevail. War roiled throughout Asia and Europe, but in America, the economy was on the rebound after the long Depression and an air of hopefulness had finally returned.

The summer of 1939 was a festive one in the Thousand Islands. The numerous boatyards turned out a splendid array of new runabouts and cruisers. There were grand parties and regattas. It was difficult to tell if people were in denial about the inevitably of war or if they simply wanted to have one last hurrah before the firing and fighting began.

The boatyards of Alexandria Bay continued to roll out pleasure boats right through the summer of 1941. But these were boats that had been ordered prior to the escalation of tensions in Europe. By the end of 1941, the famed boatyard Fitzgerald & Lee, builders of *Finesse* and *Vamoose* and many other classic Thousand Islands boats, closed its doors for good.

Many other boatyards also went out of business during the war years. One of the few to survive was Hutchinson Boat Works. Hutchinson Boat Works survived by winning government contracts to build yard patrol boats to patrol the coastlines of the United States.

Charlie Lyon had hoped and prayed for a negotiated peace. He had seen what war had wrought during World War I. A second world war, he feared, would likely be even more destructive. Both angry and sad when a negotiated peace did not come, he knew that America would get dragged into the war and that it would be a long time before life returned to normal.

Still, Charlie, a fervent patriot, stepped up and did what he could for the war effort. He raised money and awareness. Seventy-two years old when the Japanese attacked Pearl Harbor, Charlie leased the *Vamoose*, his pride and joy, to the US Navy for $1 for the duration of the war. The custom commuter would be used as a patrol boat and later as a launch for a decorated admiral. Never again would *Vamoose* be seen on the St. Lawrence River.

Sailing became the preferred nautical activity in the Thousand Islands after gas grew difficult to procure as the war wore on. Rationing became so strict by the summer of 1944 that most St. Lawrence River pleasure boats never left their drydocks.

World War II had a powerful, emotional, and financial impact on both the year-round residents and the summer visitors to the Thousand Islands. Fortunately, America would prevail over the Axis Powers, and once again, there would be reasons to celebrate.

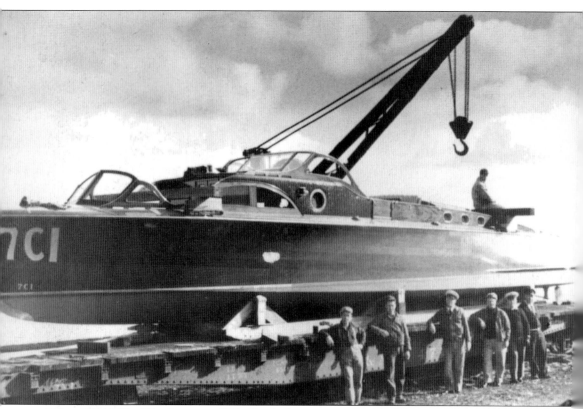

When World War II broke out in 1939, Charlie Lyon was extremely disappointed. He knew it was a matter of time before the United States would be involved. The war greatly impacted America. Gas and food were rationed, and travel outside of the country was limited. After the attack on Pearl Harbor in December 1941, Charlie immediately offered *Vamoose* up for service. She was never seen in the Thousand Islands again. She is shown here with her wartime registration number. Chauncey Burtch can be seen on the far right, leaning up against the railroad car. Bill Aiken is sitting on the boat.

Sailing became one of the more cost-effective ways to enjoy the river. Charlie's motorized sailboat *Willkie* is shown here.

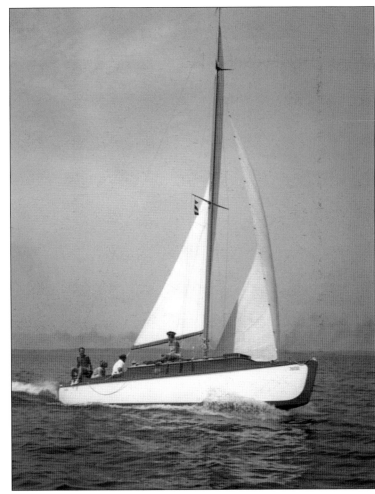

In 1939, Fitzgerald & Lee built *Skol*, a Hacker-designed triple-cockpit runabout. *Skol* is still regarded as one of the most beautiful boats ever built in Alexandria Bay. (Courtesy of the Antique Boat Museum.)

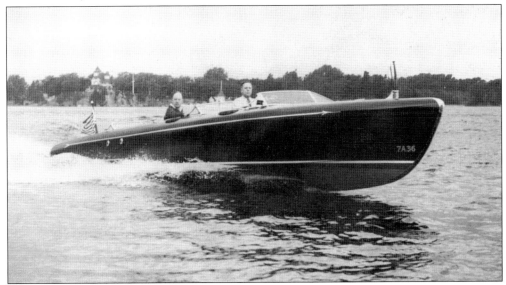

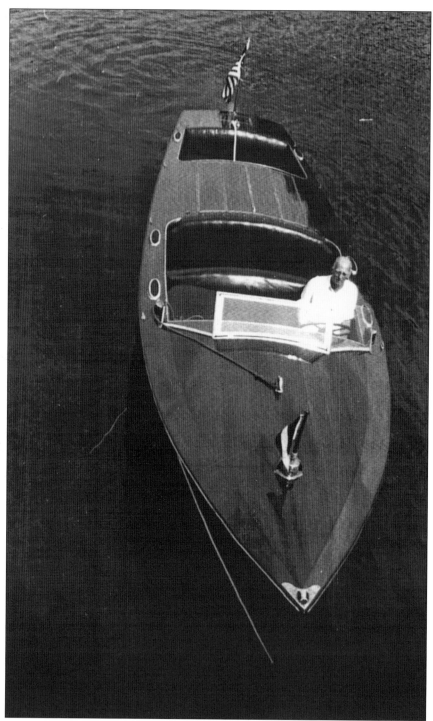

Archie Quarrier's *Miss Q* was one of the fastest boats in Chippewa Bay for over 20 years. She was designed by John Hacker and built by Hutchinson Boat Works prior to World War II. Charlie and Archie were fiercely competitive. Charlie was one of Mrs. Quarrier's beaux growing up. This only fueled the competition.

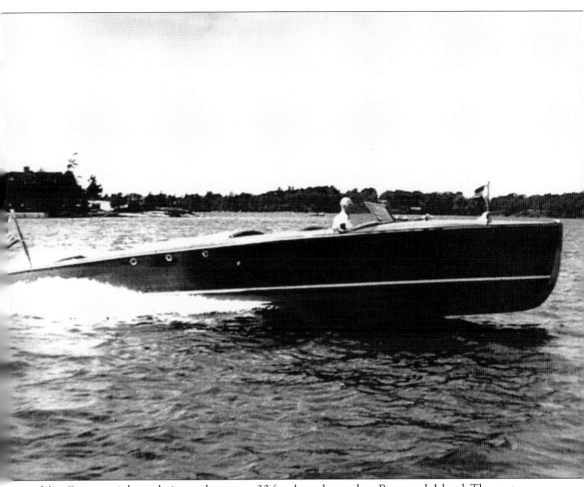

Miss Q was a triple-cockpit runabout over 30 feet long, housed on Ragnavok Island. The custom-built Hutchinson had a 500-horsepower Lycoming marine engine. She idled at 10 knots and was one of the fastest boats in the Thousand Islands. Charlie's next boat would be designed to not only beat *Miss Q*, but also to be the finest boat on the entire St. Lawrence River.

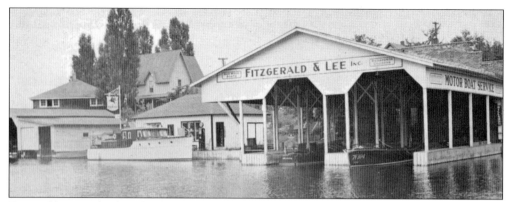

Fitzgerald & Lee built its last custom boat in 1941. John Hacker designed the 22-foot runabout *Skid* for J.S. Hammond. She was an instant Thousand Islands classic. (Courtesy of the Antique Boat Museum.)

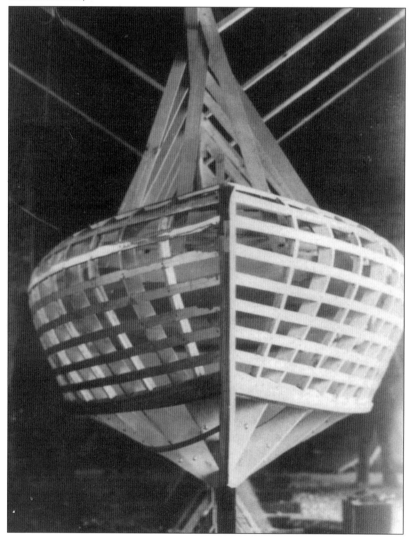

Skid's framing is shown here. She was built in the upright position, which was very unusual for the time. (Courtesy of the Antique Boat Museum.)

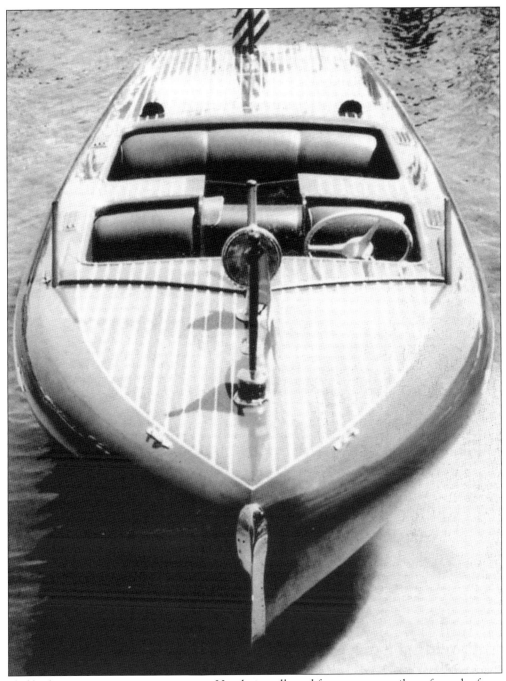

Skid had a unique seating arrangement. Her design allowed for guests to easily go from the front cockpit to the back. With America being brought into World War II in 1942, Fitzgerald & Lee closed its doors for good. This boat shop would be regarded as one of the finest in the area. (Courtesy of the Antique Boat Museum.)

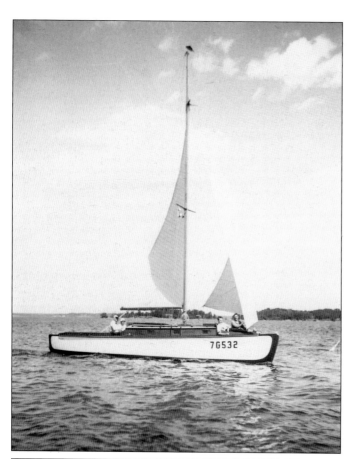

Charlie's other sailboat, *Sarge,* is shown here. Note the large registration numbers; this was required during the war years. The cabin of *Sarge* had couch seats and a windup record player.

The boat below is Charlie's hardtop Gar Wood limousine called *I.C.* Charlie had this boat for over 20 years.

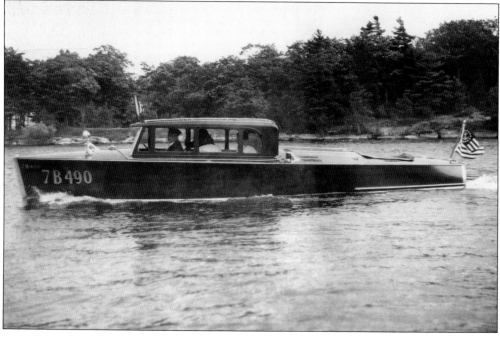

The original Gar Wood *Fifi* was traded in for a more practical, hard-topped one. This was done prior to the United States involvement in World War II. The original boat would not have been used as much due to rationing.

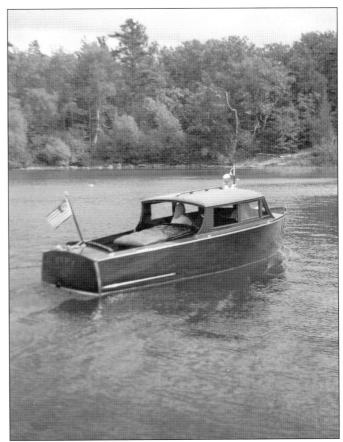

Charlie Lyon is seated below with the Ogdensburg chief of police. The poster above the door reads, "Buy Defense Stamps and lick the other side."

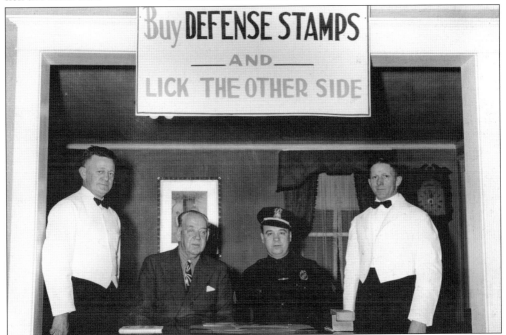

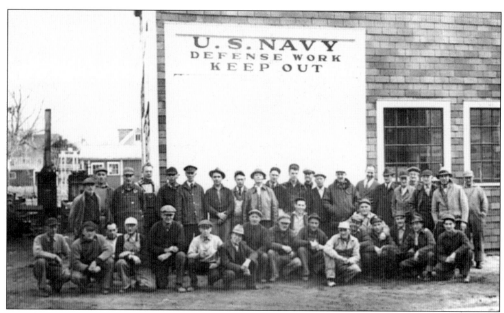

Hutchinson Boat Works received a government contract to build yard patrol (YP) boats for the war effort in June 1941. Over 200 men were employed at this time, with crews working around the clock to meet the strict deadlines. (Used with permission by Alexandria Township Historical Society.)

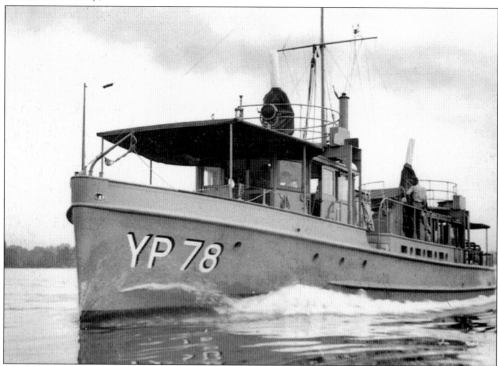

YP-78 and YP-79 were built side by side. These boats were 75 feet long and capable of 20 miles per hour. The military provided 24-hour security surveillance for Hutchinson Boat Works during this time. (Used with permission by Alexandria Township Historical Society.)

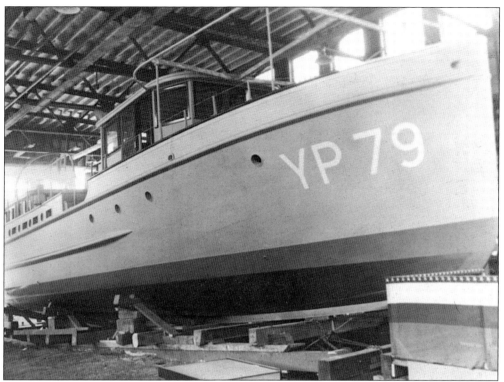

Hutchinson Boat Works was awarded the Army-Navy E Award for its excellence in production of war equipment. (Used with permission by Alexandria Township Historical Society.)

YP-385 was the last yard patrol boat completed by Hutchinson Boat Works. The company now stood its ground as the last great boat shop in Alexandria Bay. (Used with permission by Alexandria Township Historical Society.)

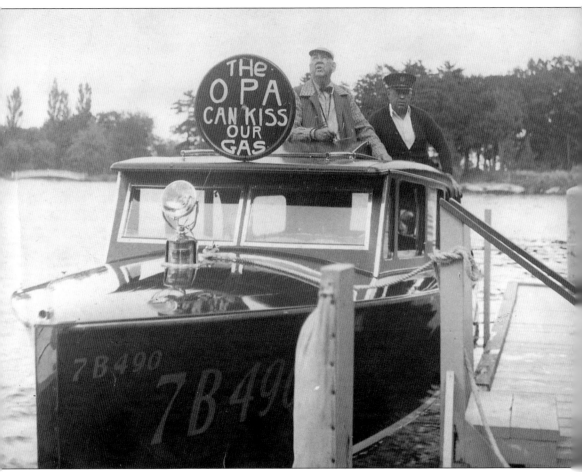

Charlie Lyon was a devout patriot. He was also a practical joker. He would pull stunts like these to get a reaction. The OPA was the Office of Price Administration, established by the federal government in 1941 to regulate prices of goods and services and control rationing of scarce commodities during the war. Charlie had this sign hung up on the front of the *I.C.* This photograph was taken from the dock at Oak Island; Chauncey Burtch is in the background.

Charlie had sailed his way through the war years. The Thousand Islands had been forever changed. Going forward, Charlie Lyon wanted to show the river community he was still king.

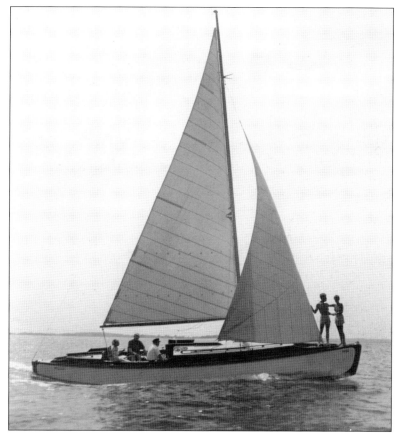

By the end of the war, Charlie had added a separate wing with five rooms to the house on Oak Island. Two of the rooms had cathedral ceilings. One was for playing bridge, and the other was a new bar.

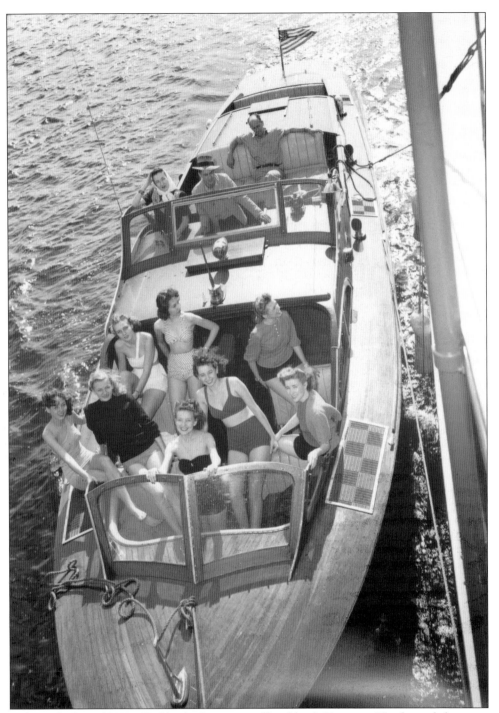

At the end of World War II, Charlie Lyon was offered back *Vamoose*. He claimed she was in disrepair, covered in gray paint, and not worth the money to restore. It is entirely possible that the king of the St. Lawrence exaggerated this so he could build *Pardon Me*. In this photograph, there is a group of Suzanne Saunders' models on board *Vamoose* in 1946 at Gibbs Shipyard in Jacksonville, Florida. (Courtesy of State Archives of Florida.)

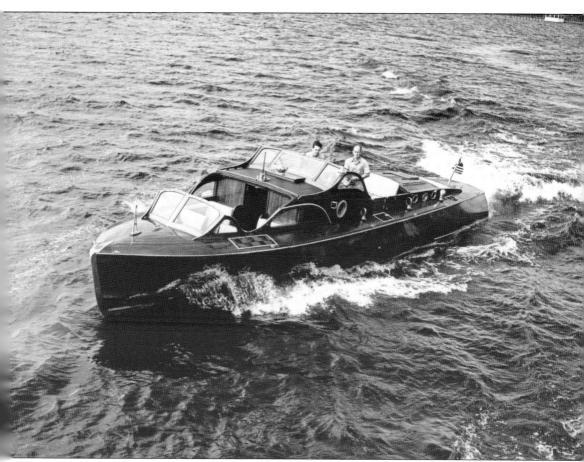

Vamoose is shown again in 1946 in the waters of Florida. It is comforting to know that someone took the time to restore the 44-foot commuter after her service to the country. Many of the boats that were abandoned by their owners after the war were sold at auction or sent to scrapyards. Someone clearly appreciated *Vamoose* for what she was. Maybe they did not know she was a Thousand Islands classic, but her beauty was certainly recognized. (Courtesy of State Archives of Florida.)

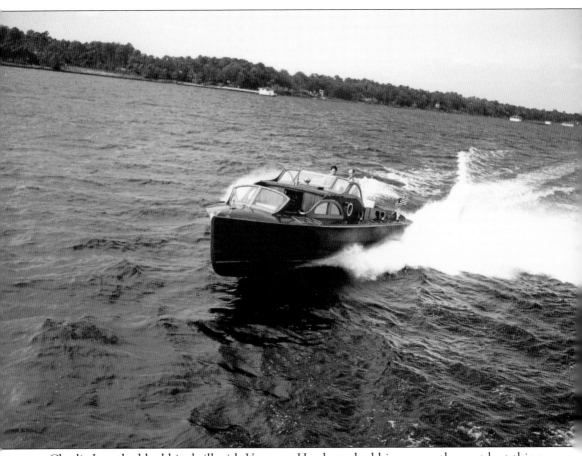

Charlie Lyon had had his thrill with *Vamoose*. He always had his eyes on the next best thing. When World War II came to a close, he felt compelled to make a statement. The country was in celebration, and Charlie made plans for a new boat that would shock the Thousand Islands community. *Vamoose*, on the other hand, would never return to the St. Lawrence River. Her exact location today is unknown. (Courtesy of State Archives of Florida.)

Seven

PARDON ME

Finally, inevitably, the war ended. Between Pearl Harbor and V-J Day, the United States suffered more than a million causalities, dead and wounded. Life in America had been irrevocably changed. An innocence had been shattered by the excessive death and destruction.

Up and down the St. Lawrence River, life slowly went back to normal. The summer people returned. Pleasure boats could once more be seen on the river. There were tennis matches and sailboat races, cocktail parties, and talk of new powerboats.

Charlie Lyon, in his own inimitable style, announced the days of sacrifice and austerity were over. And in his next breath, he declared his intention to build a boat to celebrate America's victory over Germany and Japan. The new boat would be a testament to America being the world's premier power.

Charlie went straight to John L. Hacker. The naval architect, deep in his sixties, listened to Lyon's vision for a grand Thousand Islands runabout and immediately started designing. This time, rather than Fitzgerald & Lee, Charlie gave the contract to build his new speedboat to Hutchinson Boat Works in Alexandria Bay.

The boat was christened in the summer of 1947. Across the transom, it read "Chippewa Bay." *Pardon Me* was the perfect name for the colossal mahogany runabout. Forty-eight feet from stem to stern with a beam of almost eleven feet, the *Pardon Me* shocked at first site. It looked, and somehow even felt, larger than its dimensions. The formidable bow, the excessively curved barrel back, and the smooth and rounded gunwales all gave the *Pardon Me* an aura of nautical majesty.

Charlie had told John Hacker he wanted a boat "both beautiful and powerful," and without question, the marine architect delivered on both counts. All that awe-inspiring beauty was pushed through the water with a massive Packard V-12 4-M marine engine, producing in excess of 1,500 horsepower. When all went according to plan, *Pardon Me* could exceed 60 miles an hour as she skimmed the surface of the St. Lawrence River.

Often, however, things did not go as planned with the *Pardon Me*. The giant runabout definitely had its share of problems. Charlie would, in fact, wash his hands of the whole project just months after the boat's launch.

But no matter. The king of the St. Lawrence had proved that, after the long and destructive war, America was back and would, going forward, be driven by dreams and ingenuity.

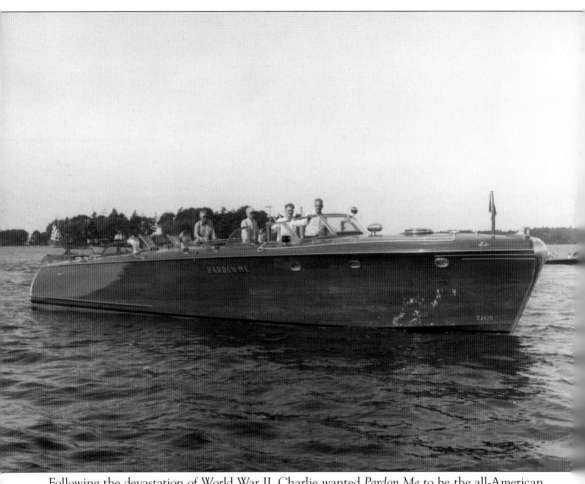

Following the devastation of World War II, Charlie wanted *Pardon Me* to be the all-American statement. This photograph is of the one-of-a-kind Hutchinson on her first cruise in August 1947. She was launched missing her chrome strip and with only four coats of varnish. (Courtesy of Mariners' Museum.)

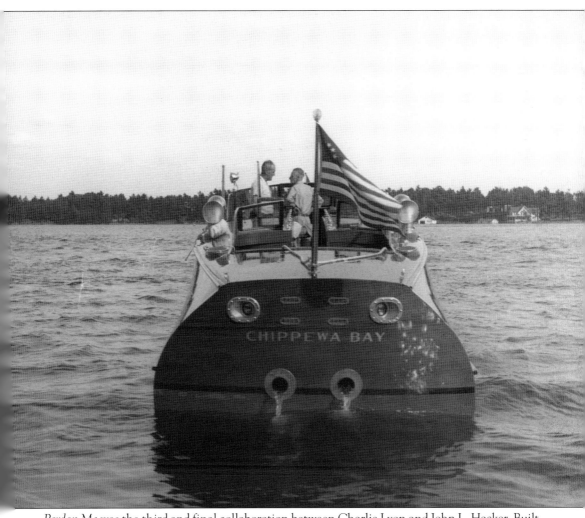

Pardon Me was the third and final collaboration between Charlie Lyon and John L. Hacker. Built by Hutchinson Boat Works in Alexandria Bay, she was 48 feet long and capable of speeds over 60 miles per hour. At 78 years old, this would be Charlie's last mahogany monster. She proudly boasted Chippewa Bay across her stern. (Courtesy of Mariners' Museum.)

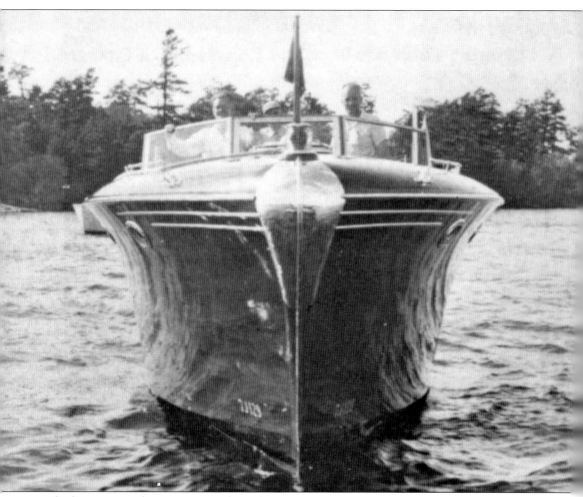

The line was "Pardon me, as I pass by." Charlie wanted to let the Thousand Islands community know that he was still king. The boat was supposed to be ready for the Fourth of July in 1947. Charlie Lyon wanted to showcase his custom speedboat for everyone to see. Unfortunately, that did not happen, and *Pardon Me* was not launched until late August. Charlie was furious. On one of the initial test runs, the Packard motor's torque twisted the pitch out of the propeller. (Used with permission of the Antique & Classic Boat Society, Inc.)

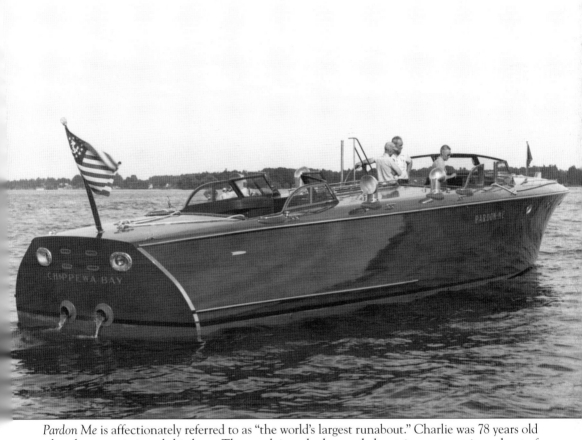

Pardon Me is affectionately referred to as "the world's largest runabout." Charlie was 78 years old when he commissioned this boat. That explains why he needed a staircase to get in and out of her. In this photograph, one can clearly see the handrailing. Hacker's design specifications covered a dozen or more pages. By the time the project was started, he had not completed the drawings. This would lead to numerous delays. (Courtesy of Mariners' Museum.)

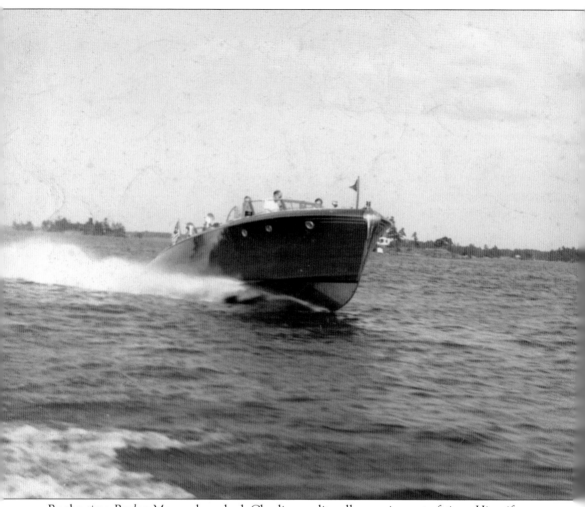

By the time *Pardon Me* was launched, Charlie was literally running out of time. His wife was beside herself about how much money he was spending. She would yell at him and say, "You're spending enough money to support five American families for a year." Charlie wasn't worried about the money. Whatever it took, he wanted the greatest boat the Thousand Islands has ever seen. He was hoping *Pardon Me* would win Helen over.

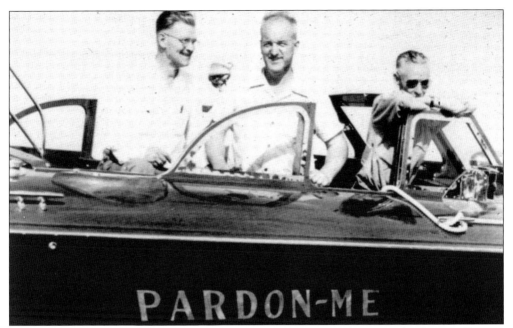

This photograph shows the original block letters. From left to right are Fred Baker, Ray Rogers, and an unidentified Packard engine mechanic. (Used with permission of the Antique & Classic Boat Society, Inc.)

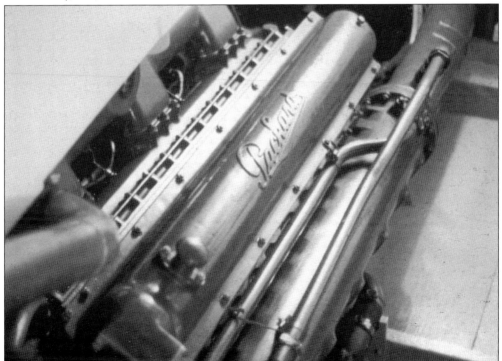

Pardon Me's V-12 Packard marine engine is shown here. She runs on 100-octane aviation fuel. This was a challenge to find in Alexandria Bay in 1947. She is capable of holding 600 gallons of fuel, and at high speeds, she uses 100 gallons an hour. (Courtesy of the Antique Boat Museum.)

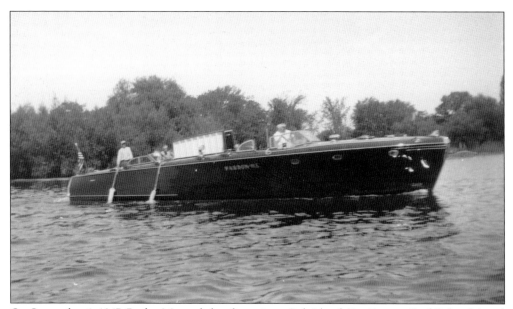

On September 1, 1947, *Pardon Me* made her first trip to Oak Island. Ray Rogers, Fred Baker, Marcel Root, and a Packard engine mechanic drove her down from Alexandria Bay. She is pictured here, with her hatches up, in the Lyon's bay on Oak Island.

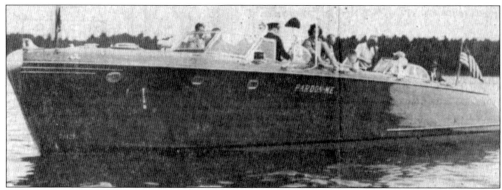

On Charlie's first ride, there were 12 people on board. Cap drove her, and she did not perform well. The Packard motor proved that it had a mind of its own. In this photograph, Chauncey Burtch can be identified by his captain's hat. Fifi is seated on the staircase. (Courtesy of the *Watertown Daily Times*.)

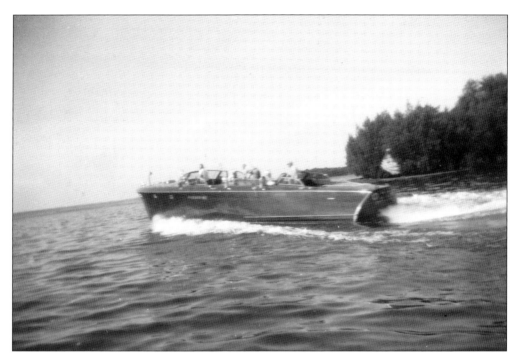

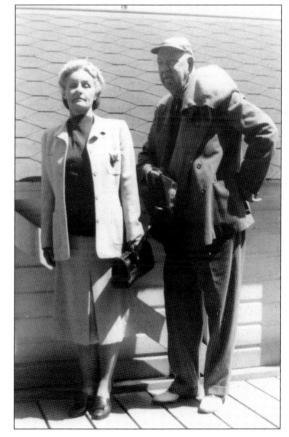

Pardon Me is pictured leaving Oak Island for the first time. The day was a disappointment because she did not perform as expected. At one point during the ride, the engine stalled, and before the controls could be adjusted, *Pardon Me* leaped back to life. The only 100-octane fuel they could get their hands on in 1947 was very poor quality. This without doubt contributed to some of the engine problems.

Charlie and Helen did not see eye to eye on the *Pardon Me*. She thought it was a complete waste of money and refused to ride on the boat for the first five times *Pardon Me* came down to Oak Island.

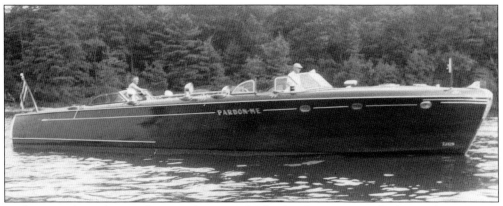

Pardon Me is shown here in the Lyon's bay on Oak Island as she was originally designed. Ray Rogers is at the helm; Fred Baker is in the stern. On one of Charlie's rides, there was almost a collision with a tour boat. Cap was frantically spinning the wheel, but *Pardon Me* was not responding. Charlie was so nervous he picked the wart off the back of his hand.

 September 1st.
 Monday. Arthur, Katharine, Patsy Dick Cottrell Boat Pardon Me came down
 for first time. Rogers and mechanicse on board. Margo, Fifi and four
 O'Neils and Charlie went for ride. Margo nearly missed her train, Bill
 drove her to Philadelphia in his car, taking Peg and Billy.Turkey supper
 Tues. Windy rainy day. The Craigs took us to Canusa for dinner. They
 had the Palmers and Phil and Jo Ella. Had drinks at Gladys first. Louise returned
 Wed 3.
 Thurs 4. Gussie went to Ogd
 Fri P M Boat came down Mr Wood Charlie and Bob Wood took a ride.
 Sat 6. Charlie and I went to Ogd. Brought Gussie back
 Sun 7. Hannah, Geo Three Kelloggs came to Island at 2. Charlie took
 them for a ride, and Hannah stayed with me.. They seemed thrilled with the
 Pardon Me. Charlie took us all to supper at T I Club that evening.
 Mon 8
 Tues 9 Charlie took the Quarriers and Knaps for a ride on Pardon Me.
 Wed 10
 Thurs 11 Edgar came up .. Little Charlie can swim without his Lifie.
 Fri 12
 Sat 13. Jean and Ted Gage arrived at 2:30 Mac came up with Edgar Charlie
 had Boat down, took Gages, Bennie Ellen Shirley West and Fifi for ride.
 Shirley stayed to swim and for dinner. Heavy storm after dinner. We played
 "Society Crap"
 Sun 14. Mid, Fifi L C are leaving this P M. Cecil,B Kath, had lunch on
 veranda with us, and Gladys, Howard Phil Jo Ella and Gages and I went
 for long ride on Pardon Me. It was my first trip. Jean Gage stayed with
 Mildred Fifi and Mid tried to leave before we returned but did not suceed.
 Mac drove them to Philadelphia in brown car. Gages are here.
 Monday .5. Charlie took us for trip around International Rift. Lovely
 day. We played bridge in evening.

A page from Helen Lyon's 1947 summer log is shown here. On Sunday, September 14, she notes that she and several others "went for long ride on *Pardon Me*. It was my first trip." The custom speedboat never came back to Oak Island. Charlie would take one more ride, and then the project was over.

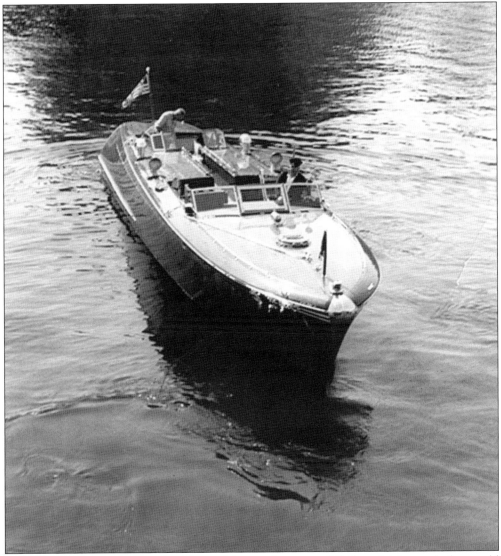

Cap did not like driving *Pardon Me*, and for good reasons. While at high speed, she would unexpectedly lurch hard to port; the steering, at times, was erratic; and the Packard motor could be unpredictable. (Courtesy of the Antique Boat Museum.)

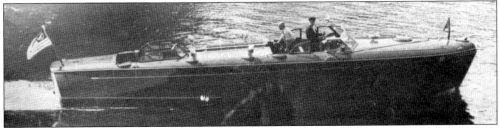

In these photographs, Cap and Ray Rogers can be seen leaving Alexandria Bay. These are some of the few photographs of *Pardon Me* with her original chrome and block letters. (Used with permission of the Antique & Classic Boat Society, Inc.)

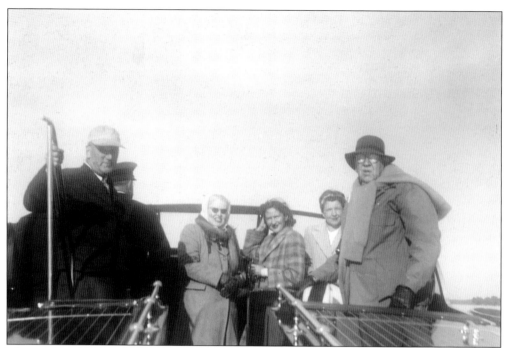

This is the only photograph of Charlie Lyon on *Pardon Me*. Neither he nor Ray Rogers could muster a smile. After the ride, Cap told Charlie, "Mr. Lyon, I'll never drive that boat." It was the nail in the coffin. She was pulled at the end of that season with her problems unresolved.

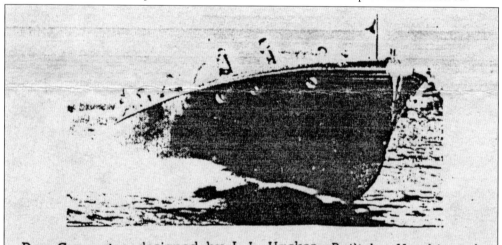

Day Commuter, designed by J. L. Hacker. Built by, Hutchinson's Boat Works, Inc. **New Boat.** 47' by 10½' all mahogany hull. Packard 12 cyl. 1500 H.P. motor, hydraulic controls. Speed 55 M.P.H. Lux C02 system. Price $36,000.00. Must be seen to be appreciated. Owner disposing of boat on account of health.

HUTCHINSON'S BOAT WORKS, Inc., Alexandria Bay, N.Y.

By the spring of 1948, she was put up for sale. This ad from *Motor Boating* magazine reads, "Owner is disposing of boat on account of health." This was not true; Charlie had just had enough. He had spent close to $50,000 on the project.

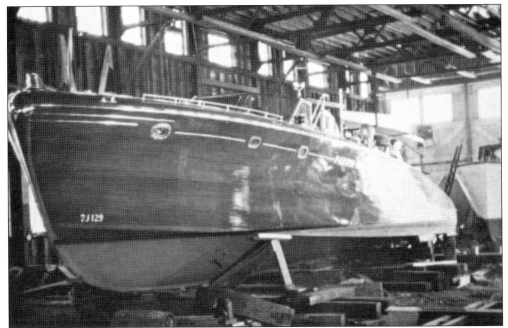

Helen's sister Margaret Griffin summed up the project like this: "He got his thrill and then it was over. Actually, I think he had more fun watching it being built." *Pardon Me* sat for sale at Hutchinson Boat Works for three years. (Used with permission of the Antique & Classic Boat Society, Inc.)

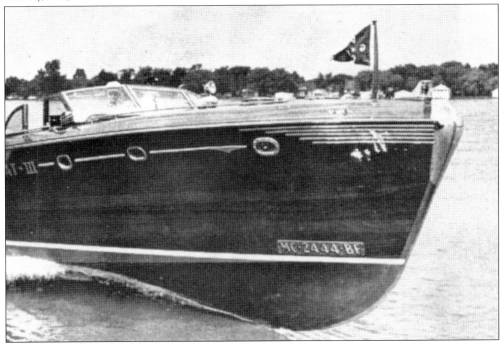

In 1950, *Pardon Me* was finally sold to Dick Locke. Locke took *Pardon Me* to Michigan, redesigned the chrome, and changed her name to *Lockpat III*. (Used with permission of the Antique & Classic Boat Society, Inc.)

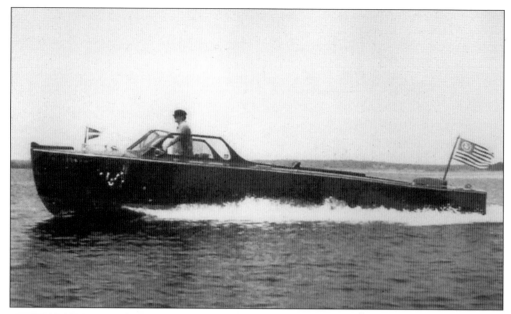

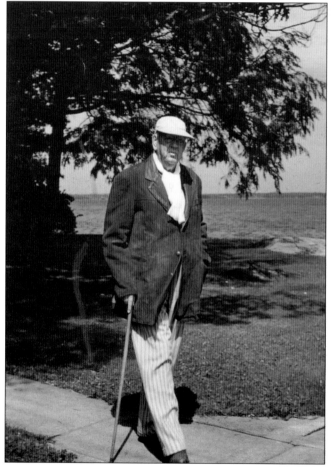

Following the *Pardon Me* project, Charlie had Hutchinson Boat Works build him a custom 28-foot utility called *Nibbles*. This boat was the only 28-foot utility ever made. It has been rumored that Hutchinson Boat Works made Charlie pay cash, up front.

The Chippewa Yacht Club unanimously named Charlie Lyon honorary commodore for life in 1952. This distinctive honor is rarely given out by the yacht club.

Eight

CURRENT HISTORY

Essentially, a boat is anything that floats and moves people or goods on top of the water from one place to another. Boats have been around a while. Archeologists have unearthed the remains of log boats constructed hundreds of thousands of years ago.

Boats were built to cross rivers and lakes. Larger boats with keels and sails were built to cross seas and oceans, to explore the far reaches of the planet. Almost three-quarters of the earth is covered by water. Long before planes, trains, and automobiles, boats provided transportation for humans who wanted to discover new places, new people, and new ideas.

For centuries, the St. Lawrence River was used as a watery interstate. First the river and then the seaway carried people and goods from the Atlantic Ocean all the way to the Great Lakes. Still today, the St. Lawrence River is responsible for the transportation of close to 50 million tons of cargo every year. Stand on the shores of Cedar or Rob Roy, and one will see a steady stream of heavy freighters traversing the river. A wide variety of essential commodities like grain, steel, iron ore, and coal are carried to market via the St. Lawrence River.

Of course, the river, as this book demonstrates, has provided far more than just commerce and transportation. Starting with the arrival of Pullman, Boldt, and Lyon in the last decades of the 1800s, the St. Lawrence River, especially that region known as the Thousand Islands, became famous for its recreational amenities. Fishing, sailing, and speedboat racing all became popular activities as grand hotels and spectacular homes sprang up on the wooded islands between the United States and Canada.

The sailboats, sedans, cruisers, yachts, and runabouts that were designed and built in and around the Thousand Islands would become some of the finest examples of wooden boats ever created. The Lyon family alone was responsible for the *Outing*, *Carmencita*, *Finesse*, *Vamoose*, and *Pardon Me*.

Dixie II, *Gadfly*, *Snail*, *Wild Goose*, and *Zipper* punctuate a list of exquisite Thousand Islands boats worshipped by wooden boat aficionados the world over.

A visit to the Thousand Islands should include a stop at the Antique Boat Museum in Clayton, New York. Here, one can not only see and touch some of these incredible boats but also can take a ride and experience the thrill of gliding across the majestic St. Lawrence River in an authentic wooden runabout.

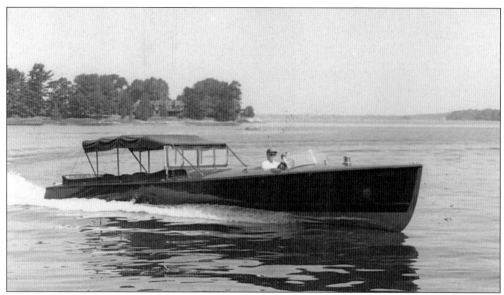

The *Wild Goose* is shown in this iconic river photograph. Hutchinson Boat Works built this 40-footer in 1914. The *Wild Goose* serves as the logo boat for the Antique Boat Museum. (Courtesy of the Antique Boat Museum.)

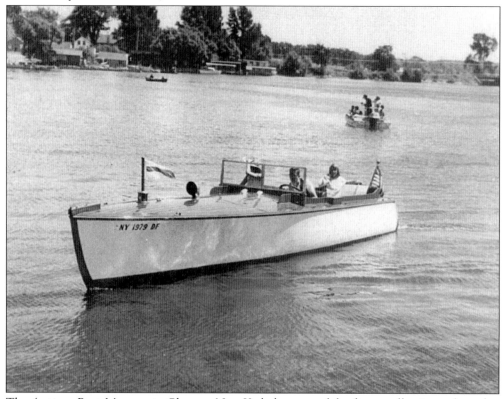

The Antique Boat Museum in Clayton, New York, has one of the finest collections of wooden boats in the world. In 1965, the first antique boat show was held to celebrate the restoration of *Idyll Oaks*, which is shown here. (Courtesy of the Antique Boat Museum.)

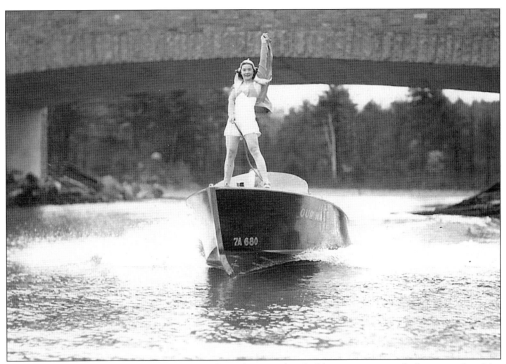

The Lou Smith Library at the museum has thousands of old magazines and photographs, like this one. *Our Ma*, built by Fitzgerald & Lee, is seen here speeding through the International Rift. (Courtesy of the Antique Boat Museum.)

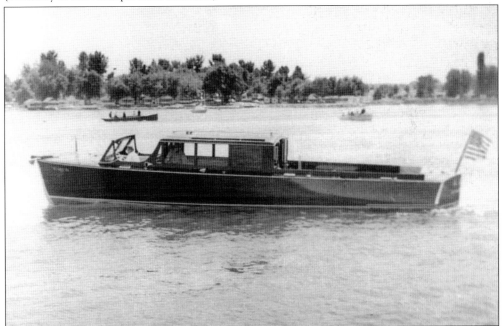

At the museum, one can see hundreds of boats that range from large yachts to small skiffs. The boat museum provides a unique opportunity to see the various types of boats that have graced the St. Lawrence River up close and personal. (Courtesy of the Antique Boat Museum.)

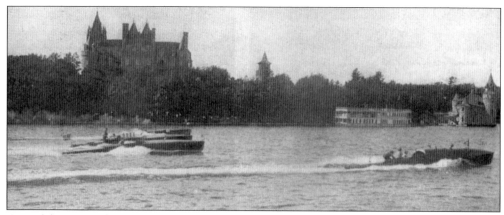

One of the most celebrated boats in the collection is *Dixie II*. She won the Gold Challenge Cup from 1908 to 1910. This photograph is from the 1909 races. Note George Boldt's houseboat tied to Heart Island. (Courtesy of the Antique Boat Museum.)

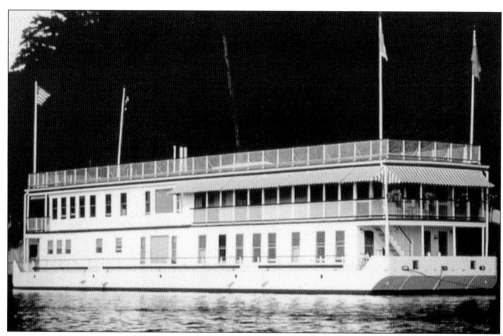

George Boldt's 106-foot houseboat *La Duchesse* is one of the museum's most popular exhibits. One can step back in time and take a guided tour through this amazing vessel. (Courtesy of the Antique Boat Museum.)

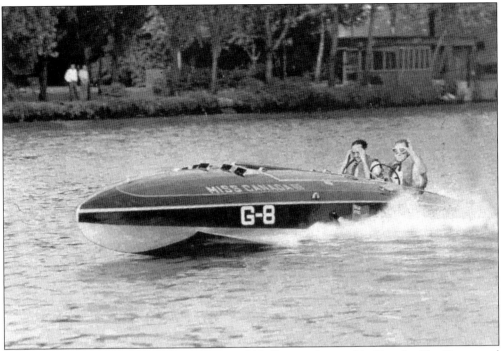

Greavette Boatworks built *Miss Canada III* in 1938. She was designed by Douglas Van Patten and is part of the boat museum's Quest for Speed exhibit. (Courtesy of the Antique Boat Museum.)

The *Wild Goose* is shown in the annual antique boat parade. She was originally named *Onondaga III* but was renamed by the Dodge family in 1928. (Courtesy of the Antique Boat Museum.)

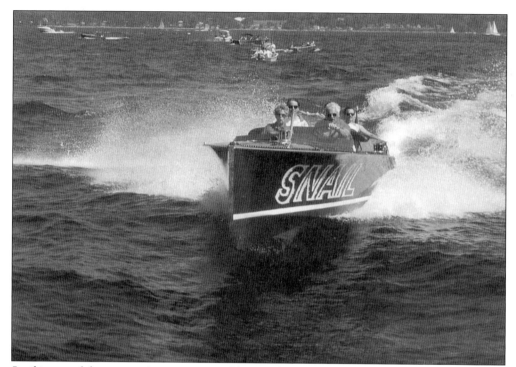

Snail is one of the museum's most treasured boats. She was built for E.J. Noble and was regarded as the fastest boat on the St. Lawrence River. (Courtesy of the Antique Boat Museum.)

Zipper (pictured) and *Gadfly* regularly take visitors out on island tours, providing the opportunity to experience the Thousand Islands from an antique wooden boat. (Courtesy of the Antique Boat Museum.)

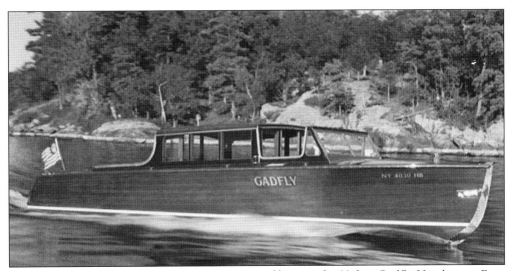

One of the Antique Boat Museum's most recognized boats is the 33-foot *Gadfly*. Hutchinson Boat Works built Gadfly in 1931. (Courtesy of the Antique Boat Museum.)

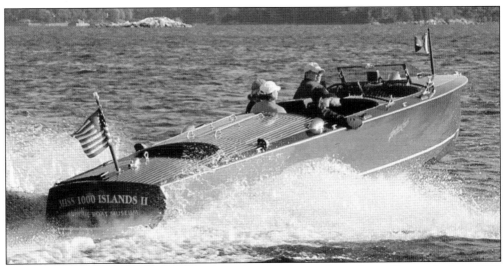

Miss Thousand Islands II is a 30-foot triple-cockpit Hacker-craft runabout. She was built in 1999 and has a V-8 Chrysler Crusader engine. This boat is available for boat rides on the river. (Courtesy of the Antique Boat Museum.)

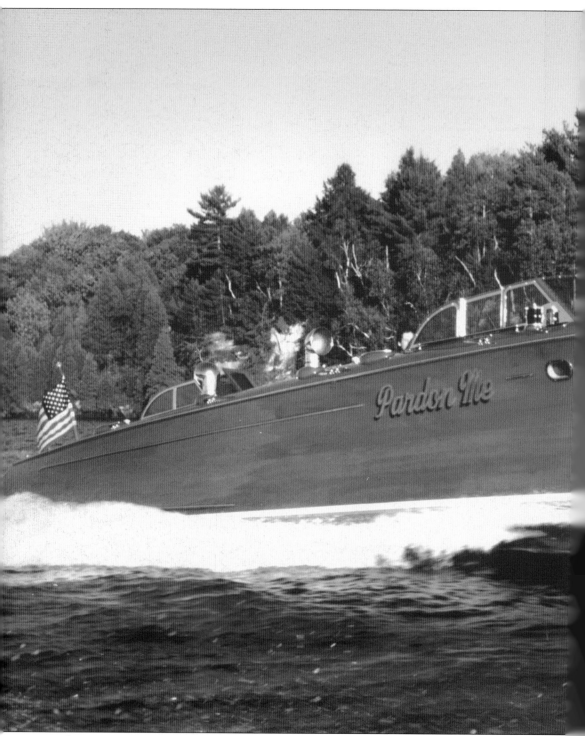

Pardon Me returned to the river in 1983 with Nick Beck at the helm. Beck had admired *Lockpat III* for years. When he tried to buy her from Locke, he was told, "Over my dead body." In 1976, that is exactly what happened. A five-year restoration was performed on the one-of-a-kind

Hutchinson at Mayea Boat Works, and she was appropriately renamed *Pardon Me*. Beck entered her in the antique boat show in Clayton, New York. Although she did not win any awards, she certainly drew a crowd.

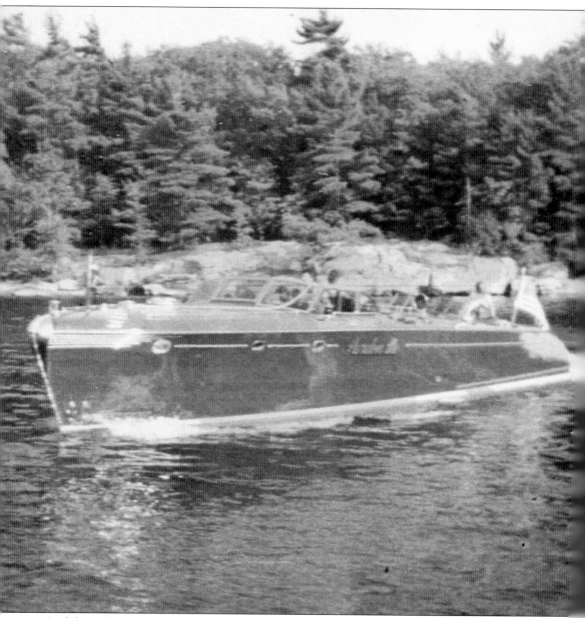

Beck brought the 48-foot mahogany speedboat back to Oak Island to give Margaret Griffin and Fifi one last ride. Margaret was quoted in the *Watertown Daily Times*: "It was nice of Mr. Beck to bring the boat back here and take us for a ride. It still is a gorgeous boat. I almost cried. I was so happy to see it." Before *Pardon Me* left Oak, Margaret gave Nick a Chippewa Yacht Club burgee. He promptly put it on the bow.

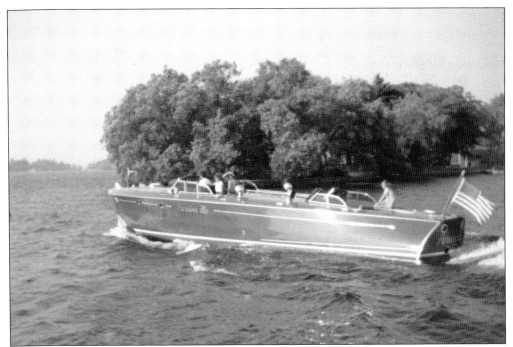

Pardon Me is pictured leaving Oak Island for the last time. She left the Thousand Islands and was sold in 1984 to William Theison. She was used sparingly in Florida until purchased by Jim and Tony Lewis.

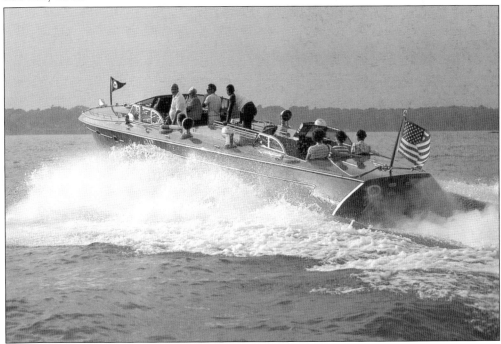

Jim and Tony Lewis generously donated *Pardon Me* to the Antique Boat Museum in 1986. When Jim was asked how much he paid for *Pardon Me*, he replied with the following J.P. Morgan quote: "If you have to ask how much it costs, you can't afford it." (Courtesy of *Classic Boating* magazine.)

Discover Thousands of Local History Books
Featuring Millions of Vintage Images

Arcadia Publishing, the leading local history publisher in the United States, is committed to making history accessible and meaningful through publishing books that celebrate and preserve the heritage of America's people and places.

Find more books like this at
www.arcadiapublishing.com

Search for your hometown history, your old stomping grounds, and even your favorite sports team.

Consistent with our mission to preserve history on a local level, this book was printed in South Carolina on American-made paper and manufactured entirely in the United States. Products carrying the accredited Forest Stewardship Council (FSC) label are printed on 100 percent FSC-certified paper.